DATE DUE			JUN 0 6
GAYLORD			PRINTED IN U.S.A.

MEDIAEVAL FOLK IN PAINTING

Photography by Andrew Elton. Styling by Lisa Hilton

✠ ANN JOHNSTON ✠

First published in 1994 by
Sally Milner Publishing
558 Darling Street
Rozelle NSW 2039 Australia

© Ann Johnston, 1994

Photography by Andrew Elton
Styling by Lisa Hilton
Author photograph by Benjamin Huie
Design by Judy Hungerford
Film by Litho Platemakers
Printed in Singapore by Tien Wah Press Pte Ltd

We would like to thank the following
for the loan of items which appear in the photographs:

Boyac Fabrics, Paddington NSW
Lincraft, Sydney NSW
South Pacific Fabrics, Paddington NSW
Home & Garden, Sydney NSW
Sandy de Beyer, Mosman NSW
Mosman Antique Centre Mosman NSW
Orson & Blake Woollahra NSW

The marbled paper used in this book is from The Paper House

National Library of Australia
Cataloguing-in-Publication data:

Johnston, Ann (Ann C).
Mediaeval folk in painting.

ISBN 1 86351 138 5

1. Figure painting – Technique. 2. Painting, Mediaeval.
3. Folk art. I. Title. (Series: Milner craft series).

757

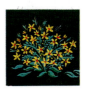

DEDICATION

to my mother

LILLIAN MAY DOBLER

who had an appreciative

and creative soul

and encouraged her children's gifts

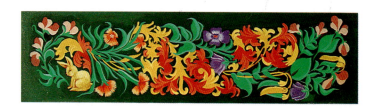

CONTENTS

ACKNOWLEDGEMENTS

~

My particular thanks are due to a number of people whose assistance was indispensable during the book's preparation.

To my husband Bill, and our children Luke and Clare, who have been my greatest helpers and my most trenchant critics. The combination of my background in art and Bill's studies in classics and modern languages has been a fortunate one. Although, there was one mad moment when he managed to wipe almost the entire manuscript from the computer disk and all that remained, to be churned out by our printer, was the title of an anonymous late Middle Ages poem, *Quia amore langueo*, 'Because I languish from love'.

To Bernadette Jackson, who typed and retyped much of the manuscript and reassured me that the project was a worthwhile one.

To Joy Sherbon, for proofreading the text and for offering valuable comment and suggestions.

To Audrey Craine, whose unfailing encouragement was one of the reasons that I began the whole project.

To my students at Cluny Workshop, whose enthusiasm for mediaeval painting convinced me to focus on mediaeval themes, and who have been my sounding-board for many of the book's projects.

To J. U. for encouraging me to explore his theories on 'being an artist'

For more information, please contact Ann's studio,
Cluny Workshop 174 Majors Bay Road, Concord NSW 2137 Australia.

INTRODUCTION

~

The name, Middle Ages, has to be one of the most broad descriptions ever given to an era of human experience. It is a loose, generic term that describes approximately half the life of Christianity, from the fifth to the fifteenth centuries. It is a span of time which we tend to consider from the European aspect, mostly ignoring the vast wealth of other cultures and civilisations that existed during the same ten centuries, in Asia, the Middle East, South America.

The twentieth century has seen a remarkable impetus to the study and understanding of the Middle Ages, most importantly through the printing and diffusion of huge quantities of documents: chronicles, narratives, illustrations, poetry and romances, philosophical and theological works. These, along with the ever-burgeoning contributions from anthropological and archaeological research, mean that we can now look at the history of mediaeval Europe in a way that previous generations would not have dreamed possible.

Those living in twentieth-century western Europe are continually connected with the Middle Ages, and particularly the High Middle Ages, in aspects of their daily lives. Many Europeans walk down streets fundamentally unchanged since the twelfth and thirteenth centuries; they worship in churches essentially unchanged from the days they were constructed. Many European political, commercial, social and cultural organisations spring directly from those of the twelfth and thirteenth centuries. And therefore, some knowledge of the Middle Ages, and an awareness of its importance, is of great relevance to non-European, twentieth-century people whose civilisations are based on those of Europe.

In his foreword to the *Oxford Illustrated History of Mediaeval Europe*, George Holmes emphasises two broad distinctions for better understanding the period we call the Middle Ages. The first is a geographical distinction, one between northern Europe and the Mediterranean lands; the second is the significance of shift in centres of civilisation from the east to the west throughout this period. If we add to that, the generally accepted time division between the Dark Ages of 400-900 AD and the High Middle Ages of 900-1200 AD, we have a good general framework for study.

One significant observation can be made on modern European civilisation, and perhaps on modern western civilisation in general, promoted by an understanding of what the Middle Ages brought about. We are witnesses, in the last decade of the twentieth century, to a Europe which is trying desperately to promote political and economic unity and play

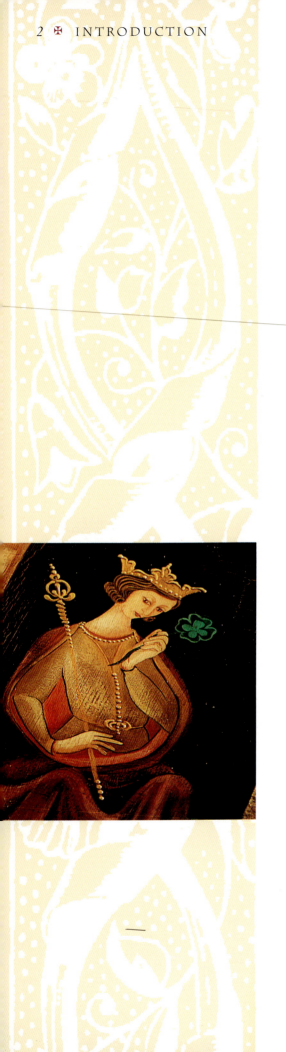

down sectional and partisan interests, as it looks out on a world so much more vast and populous than in the year 1000 AD. Holmes' remark is apt when he writes:

> *The history of the Middle Ages thus leaves us, above all, with a sense of the extraordinary vigour and creativity which derives from the fragmentation of power and wealth into innumerable centres, competing and expanding into different and unexpected directions. The places where political fragmentation was most complete, such as Tuscany, the Low Countries, and the Rhineland, were perhaps the most creative.*

Anyone who delves into the manuscripts, the painting, the architecture and the various other forms of artistic expression of the period, the early centuries of which are referred to as the Dark Ages, cannot but be fascinated. Its visual expression puts us in immediate contact with the beauty, the inequality, the complexity, the savagery, the sheer human interest of the lives of both ordinary and extraordinary people. Even a cursory look at some people of the time can give a sense of that richness and vigour of life.

THE PLANTAGENETS

In terms of power and politics, when Henry of Anjou became Henry II of England in 1154, there began a reign of some 330 years of the House of Plantagenet, which ended with defeat at the battle of Bosworth and the subsequent accession to the throne of the first of the Tudor kings, Henry VII. Henry of Anjou had married the formidable Eleanor, Duchess of Aquitaine, in 1152. She bore him eight children between 1153 and 1167, and incited three of her sons to rebel against their father, initially unsuccessfully. Henry himself achieved historical notoriety by falling out with Thomas à Becket, the Archbishop of Canterbury, who was slain by four knights acting to please the king. In the end, it was the armed opposition of Henry's sons, Richard and John, that caused the ageing Henry to retreat to Chinon, where he died on July 6th, 1189, reputedly of grief. The same son, Richard, was to become King Richard, known as the Lion Heart, whose absence at the Crusades was recounted in the legends of Robin Hood. And the legends probably do some injustice to King John, the youngest of Henry's sons, who was arguably a much better ruler than his brother Richard had been.

FRANCIS OF ASSISI

Almost at the same time, not so far from France and the England of the Plantagenets, an extraordinary Italian was born in Umbria, about the year 1182. Giovanni Bernadone was born into a wealthy family and lived

an unexceptional life prior to his capture in a local skirmish between the towns of Perugia and Assisi. The conversion he underwent had great importance for Francesco, (the name conferred on him because of his love of French fashions) and also for the Church, which was calling for a form of Christian life that was both simple and evangelical, and not based on monastic separation from the society of the day.

The story of the early years of the Franciscan Order, founded by Francis of Assisi (as he came to be known) makes interesting study. The image of Francis of Assisi as a figure of peace and champion of all creatures great and small, remains as fresh in the twentieth century as it so obviously was in the thirteenth. From as early as the fourteenth century, illustrations abound of his legendary affinity with wild creatures, as seen in this painting of Francis preaching to the birds, derived from an original fragment of stained glass in the Abbey Church at Konigsfelden, Switzerland.

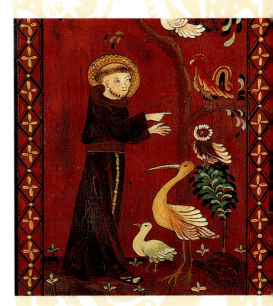

KING ARTHUR

The fascination that we find in the great stories of adventure and love from the Middle Ages we owe largely to a German knight and man of letters, Hartmann von Aue, who, along with the French poet, Chrétien de Troyes, drew on a wealth of tales and legends. Going back to Arthur, the English king of the sixth century, they took the few shadowy details that were known and put their Arthur at the centre of the Knights of the Round Table. The result was the creation of the Arthurian romance, that wonderful combination of love, honour and deeds of chivalry, in which the larger-than-life figures of the various knights struggle to find a harmonious balance between Minne (love) and Ere (honour). Many representations of 'minne' scenes exist, such as this delightful early four-teenth-century example from Heidelberg, where, in a scene that is so suggestive of the later Romeo and Juliet, the knight languishes in the arms of his beloved beneath the briar tree.

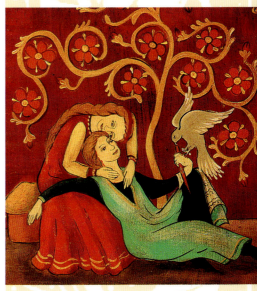

THE COMMON PEOPLE

Historical records have a tendency to concentrate on politics and power rather than on things of everyday. A great deal of the artistic legacy of the Middle Ages is no different, and yet we do have considerable insight into the way that ordinary people thought and lived their lives. On the one hand, the peasants who made up the majority of the population, lived lives of harshness and poverty; they were forced to be self-suffi-cient, and were dominated by local lords and revenue collectors. Their lives were almost owned by feudal powers, they surrendered their liber-ty in return for protection, their life expectancy was frighteningly

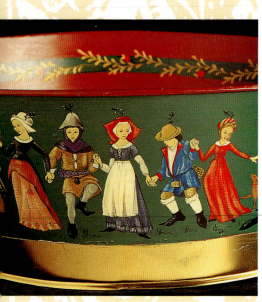

short, especially in times of epidemic such as the Black Death. They could be marched to war on a whim and in the mêlée of hand-to-hand combat, their return home would be dependent much more on luck than on fighting ability.

Yet for all that, perhaps in spite of that, the art of the period generally exhibits so much that we recognise and value. In a world that could be so uncertain and difficult, it is little wonder that people had a philosophy that alternated between *Carpe Diem* (seize the opportunity of today), and a view, which came from the Church, that this world with all its deprivation and suffering, was merely a preparation for the next. Young lovers celebrate the spring, weddings are a time of particular rejoicing, farmers and shepherds go through the routines of the summer and enjoy the fruits of the harvest. There is a sense that folk take the opportunities that occur to celebrate and be happy. One even has the impression that some of the joy in life comes from a healthy cynicism concerning the strictures of both the civil and ecclesiastical authorities which so ruled their existence.

There are two points of focus in this book; the first is delving into an enthralling period of history, the second is exploring, in a personal and practical way, some of the great themes of its art forms. It is my conviction that the greater one's personal study and discovery of the former, the more joy there will be in the latter.

WHY
MEDIAEVAL?

~

ABOUT THIS BOOK

In my final years of high school, I was fortunate enough to have as an art teacher someone who passed on to me her own love for visual arts, both as study and creative expression, and opened up for me the art of the Middle Ages in such a way that it has been a passion ever since.

That interest began with architectural structures, design and decoration, in places as different as the Byzantine world of Ravenna, with its lustrous mosaics, the Romanesque churches of France, with their beautifully stylised relief sculptures and the Gothic cathedrals of northern Europe, where stained glass panels allowed both for lighting and for decoration.

Works that had been appreciated through study became personal and treasured experiences in the course of living, working and travelling in Europe. Occasional returns to Europe during 25 years as a secondary visual arts teacher, provided inspiration for teaching art history and, more significantly, have led to a specialised interest in tapestries and manuscripts, as reflected in the projects of this book.

Mediaeval art has been a favourite area of interest throughout the whole of my teaching career, but had been largely restricted to academic study. It was an opportunity to take part in some practical classes in folk art that made an immediate connection for me between techniques which folk art has preserved and treasured, and traditional mediaeval painting skills. That inspired me to go back to original images, to adapt them using my own colour theories, trying to modify images to suit particular wooden objects so that they became conceptual works in their own right.

The projects contained in this book are a collection of more recent works that I have completed, which I hope you will enjoy painting, and which may provide inspiration for your further personal painting. They are unashamedly explorations of mediaeval themes, obviously inspired by works of the period, but there is a real sense in which they are expressions of a twentieth-century person, who seeks to draw on them in order to have an understanding of, and creative expression in, her own life.

ABOUT THE PROJECTS

I have tried to select pieces that are suitable and can be enjoyed by painters of all levels of expertise. I have graded them from 1 to 4.

1 Beginner: no real painting experience.

2 Beginner/Intermediate: some previous experience.

3 Intermediate to Advanced: brush skills required.

4 Advanced: experience in painting and brush skills required.

Do not be daunted by the apparent degree of difficulty in painting these human figures. All the projects in this book have been designed so as to guide you through the process step-by-step, and even inexperienced painters, who carefully and accurately follow the instructions, can produce most pieces and derive great pleasure and satisfaction from the finished article.

Keep the colour picture, provided for each project, in front of you as you paint.

All the specific information on techniques that you will need to know is given in the chapter that follows.

THEMES

The book has been divided into themes that cover aspects of mediaeval life; the Court, Religion, Manuscripts, Town Life, Music and Dance.

ITEMS FOR PAINTING

Many of the raw timber pieces that I have used for projects in this book are available from folk art suppliers. Some I have designed myself and had specially made. You should feel free to adapt the design to the piece you wish to use.

THAT EXTRA TOUCH

Be sure to paint the name of the piece, the period of the original and where it is to be found, on the finished article.

It is also a good additional touch to paint a little 'surprise' on the inside of the lid of a box, or the back of a screen etc. Simply take some detail of the design (a flower, a bird, for example) and paint it on. I often also include a quotation that is appropriate (there is a verse supplied for each project) for special occasions.

GENERAL TECHNIQUES

~

BACKGROUND FINISH TECHNIQUES

All surfaces need sealing. This can be done by using an acrylic sealer, a wood stain, or an acrylic background paint.

The background finish is most important. The colours and techniques used should enhance the image and should therefore relate to the image. The 'look' is purely personal. If you want a painted surface, you may choose to use either:

- a smooth finish, and therefore a simple coloured background to carry the image, or
- a rustic finish that becomes part of the image and creates interest where 'plain' images would otherwise appear.

Smooth Finish Use a wider brush or sponge brush and apply the background colour in long, smooth, even strokes of paint. The finish should be opaque, so apply at least two coats, allowing the paint to dry between. Lightly sand in between the coats.

Rustic Finish Use a wide 'roughish' 25 mm (1") brush, applying two coats of background paint. With this method, you might like to use two colours that complement each other — a light and dark, or a warm and cool etc. Apply the first colour, giving quite a thickish coat. The paint does not need to be smooth, allowing the brush strokes to show; they will pick up the antiquing later and give an old look to your project. Allow to dry but do not sand. You might like to add some crackle medium at this stage (see Crackling page 9). For a slightly different effect, use a sea sponge instead of applying the paint with a brush. It is possible to use more than two colours for this process. Wet the sponge and wring it out before applying the paint. The first colour is 'patted' on in order to cover the surface. Build up each colour, applying less of each successive colour so that the underneath colour shows through. Crackle medium can also be applied after the first colour. Sand lightly when dry.

If you want a stained finish, you may choose to use either:

- a wood stain, or
- a clear sealer

Wood Stain Finish This will allow the grain to show and will very often enhance the painting. There are times when it seems a shame to

cover a beautifully grained piece of natural timber with paint. There are so many good quality wood stains available. Choose either an acrylic stain and follow the instructions carefully or, alternatively, Liquitex makes a clear medium to which any background of flow-medium paint can be added; it also allows time to control the colour during application. To add colour to clear sealer, you can simply add water to the paint and apply the paint as a wash.

I would suggest that you use this latter technique only on small pieces because the timber soaks up a wash quite quickly and can create a patchy look on a large surface. Apply all stains with a sponge or soft cotton cloth. Sand before applying image.

Clear Sealer This is very suitable if you have a nicely grained piece of timber. An acrylic sealer should be used, either in the clear form or with colour added to it. If the latter, I would add a little water (2:1:1, sealer:water:paint). Clear sealer is applied with a brush; sealer and paint with a sponge or soft cloth. Sand before applying the image.

Distressing This will nicely age your project. Apply two coats of paint with a roughish brush. Choose two different colours that complement each other — light/dark, cool/warm etc. Using an aluminium oxide paper, sand the top colour when dry with the grain, allowing the underneath colour to show. The whole painted surface of a work may be distressed, or parts of the surface only, to give more character and interest to those sections which will not bear the final painted images.

Crackling Another method of giving your project an aged look. Crackle medium causes the top layer of paint to separate, allowing the underneath colour to show through. There are several different brands of crackle medium: some are applied to the top surface, others between coats of paint. With crackling, you can either have two different complementary colours, as for distressing, or two coats of the same colour and rely on the antiquing medium to show up the cracks.

When using the type of crackling that is applied between coats, squeeze a small amount onto the surface and spread. Brush any excess medium away at the edges and be sure that it is dry before applying the top coat of paint. The size of the cracks will depend on the thickness of the crackle applied, as well as the thickness of the paint surface. For large cracks, always apply the top coat with a brush. Do not overwork the crackle medium area because moisture in the paint will start to break down the crackle medium. To obtain finer cracks, lightly sponge on the top coat of paint, or paint on a very thin coat with a brush. If you find that cracks are bigger than you prefer, allow the top coat of paint to dry, then give another coat of paint to that area. Remaining cracks can be filled later at the antiquing stage, which will be discussed later.

APPLYING THE DESIGN

Accurately trace the pattern supplied onto a piece of tracing paper (or greaseproof paper). Position it on the prepared surface and slide underneath it a piece of transfer paper (graphite paper that comes in a variety of colours; choose a colour that will show on your work). Use a stylus or an old ballpoint pen to carefully draw over the pattern and transfer it to the surface below.

If you are using a wooden piece that is a different size from the project in the book, simply enlarge or reduce the pattern on a photocopier. Some patterns in the book will need enlargement because the original was too large for the book page size. The photocopying enlargement ratio is indicated on each pattern page.

BRUSH TECHNIQUES

Blocking

Mediaeval painting requires some blocking in of flat colour before applying the surface decoration. Blocking in simply consists of carefully filling in the area with straight opaque colour, using a flat or round brush. Use long, even, direct strokes where possible, don't 'dabble' — make the brush work. Sometimes the blocking can be smooth, at other times it is good to build up a texture with slightly thicker paint. For example, if the top decoration asks for 'side loading' or 'floating' (these terms are explained below) to achieve a delicate finish, then keep the underneath surface smooth. If there is a 'dry' brushing (see below) on top, a thicker and more textured surface underneath will enhance the dry brushing.

Dry Brushing

Dry brushing is a simple way of creating tone, that is, light and shade. It can be most useful as a method for creating folds in clothing. A flat or round brush can be used, but I prefer a 7 mm, ($\frac{1}{4}$") long-hair flat brush. Load a perfectly dry brush with paint that has been squeezed straight from the tube — do not add any water. Brush a few strokes onto an old towel or kitchen paper and then begin to move your brush in a painting movement just above your painting before actually touching the surface. Apply the paint with a very soft movement, skimming over the surface so as to just pick up the texture of the paint below. The colour you apply will usually be a lighter shade of the original colour, made by adding white. One exception might be the red range, where vermilion or yellow can be used to avoid using 'pink' on top. If you want a greater depth of colour, dry brush several tones on (approximately three) layer by layer, applying a little less paint each time, so as to allow the underneath deeper tones to show through. When adding highlights, it is important to note from the picture from which side the light is coming.

Floating

I use floating as another method of creating shadows and highlights, or painting drapery. Make a watery mixture with your paint in a deeper tone or contrasting colour, and load it on your brush. Run the side of your brush through some fresh paint that has been squeezed on your palette. Place the brush down with the loaded paint on one side and run it along the area you wish to highlight; this should create a graded tone. Blend the edge if needed. Instead of using watery paint on your brush, you can also apply a little retarder or flow medium onto the surface before starting and simply side load with a wet brush.

Side Loading

Load a round brush with paint in the usual way, forming a flat wedge shape. Run the edge of the brush through some fresh paint, usually lighter in tone. Place your brush down with the loaded paint on one side and run it along the area you wish to paint. This method is particularly effective for creating a textured highlight.

Commas

The comma is a basic stroke used in folk art and is a stroke I often use for surface decoration. Load a round brush by wiping through the edge of the paint on your palette two or three times, turn your brush and repeat, forming a wedge shape on the end of the brush. Place the brush down onto your work, making sure the hairs spread, lift the brush as you paint through the stroke, allowing the hairs to come back together so you can paint a fine tail, forming a comma shape. You may find it helpful to roll the brush slightly between your fingers as you paint out of the tail (roll anticlockwise for a left-facing comma and clockwise for a right-facing comma).

Textured Commas

To create a textured comma, load your brush as for an ordinary comma and then pick up an extra little drop of fresh paint on the tip of the brush. Place the brush down and proceed into a comma stroke leaving a textured head on the comma. I like to use textured commas to enhance the surface quality of the painting.

PAINTING FACES

The face always appears as a focal point in a painting and therefore should be painted quite carefully. Mediaeval faces are simple in style. They are basically flat and stylised and show very little evidence of the naturalistic modelled appearance found in Renaissance painting. Any face painting can be daunting but I have devised a relatively simple process that can be easily followed and applied to all the figures in this book.

1 Make a warm flesh mixture of Titanium White, with a tiny amount of Raw Sienna, and an even smaller amount of Terracotta.

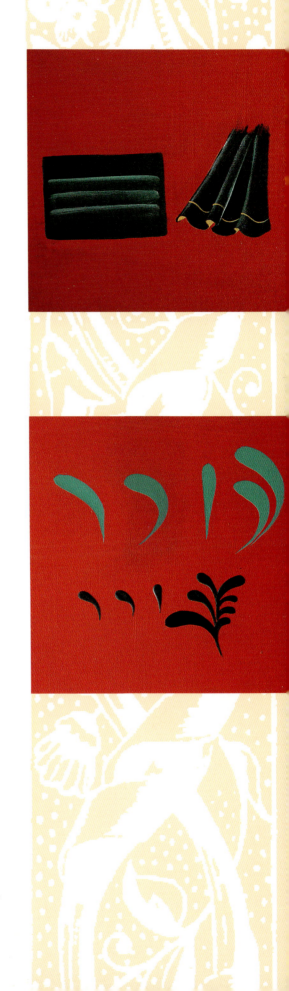

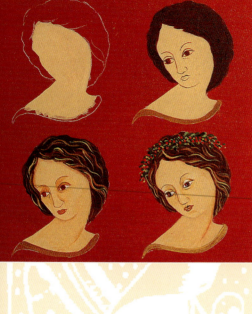

2 Build up a good opaque finish on the face area by applying 2-3 coats of the mixture. It is important that you allow the paint to dry between coats.

3 Trace on the pattern of the face.

4 Using a No. 00 or 0 round brush or a liner brush, paint over all feature lines with Burnt Umber.

5 Paint the iris in Burnt Umber.

6 Mix Burnt Sienna, Raw Sienna and White (2:2:1) and make the mixture watery. Float a wash across the following areas, using a 7 mm (¼") dagger brush or a No. 2 round:

- between the eyelid and eyebrow (concentrating more in the areas closest to the nose and blending out to the sides)
- down either side of the nose
- under the chin, blending the excess down the neck
- on larger faces, float a wash around the hairline.

7 Mix Burnt Sienna, Raw Sienna and White (2:2:1) and paint mixture across eyelid (use a No. 1 round).

8 Add White to the mixture and paint a little in the centre of the eyelid, blending either side. This will give a little 'roundness' to the eye.

9 Paint Antique White on the eyeball (either side of the Burnt Umber iris).

10 Paint in a Black pupil and add a flash of White as a highlight to the side of the pupil.

11 Paint the lips in Terracotta. Add a little White to the Terracotta and brush a small highlight in the centre of the top and bottom lip.

12 Using a No. 00 or 0, round or a liner brush 'tidy up' by repainting the Burnt Umber lines around the eyes.

PAINTING HANDS

Block hands in, as for faces; when dry, add a little White to the mixture. Dry brush on a few highlights where the light would be falling and then outline in Burnt Sienna.

PAINTING FIELD FLOWERS

Field flowers appear on three of the projects – The Lady and the Unicorn, The May Day Dancers and The Seated Musician. They can also be used to decorate around a box or inside the lid etc. Follow the instructions, using the picture on the right as a guide.

Leaves and Stems

1 Mix Phthalo Green with White and add a little Midnight Blue.

2 Use a liner brush and paint all the stems and leaves across the box.

3 Some leaves are painted with comma strokes, others as 'feathery' strokes.

4 Add White to the colour and paint a few highlight strokes on the leaves.

Flowers

Scatter the flowers in and around the leaves.

1 White with Cadmium centres:

Use a No. 2 round brush and use the side of the tip to apply the paint by lightly dabbing around in an oval shape; add a yellow dot to the centres.

2 Cadmium Yellow daisies with a Terracotta dot in the centres.

3 Dioxazine Purple with White added:

Load a No. 2 brush, form a round end on the brush and lay down a daisy petal shape; using a liner brush, paint a tiny white stroke on the tip of each flower.

4 Same flower as No. 2: using Burgundy with a touch of White added. Tip flower with White.

5 Paint a largish dot in Terracotta, add two little commas at the top and a little Cadmium Yellow 'flash' down one side.

6 Daisies:
 Ultramarine with White added; white dotted centres.

7 Cadmium Yellow largish dots with smaller white and then Terracotta dots on top.

8 Same as No. 3: painted in White with Terracotta tips.

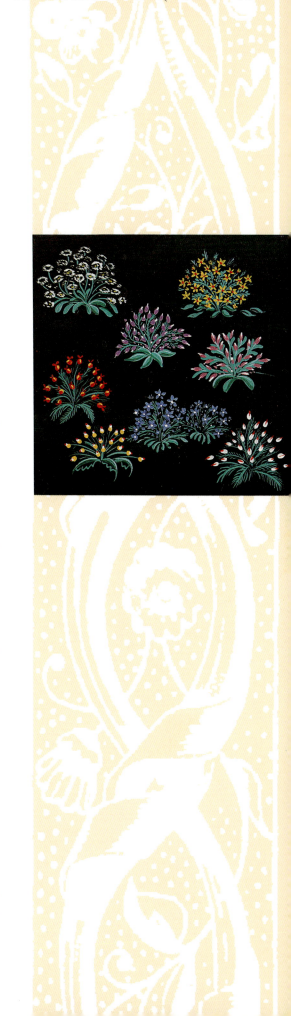

FINISHING TECHNIQUES

Ideally, before finishing, it is good to give your piece a few days to settle and cure. Finishing your work involves three processes: antiquing, varnishing and waxing.

Antiquing

Whether to antique or not is a matter of individual preference. Some pieces look better heavily antiqued, while others need only the lightest application. A happy colourful scene of May Day dancers around the maypole need only be lightly antiqued so that the painting remains

vibrant, whereas a more earthy, coloured scene, perhaps of a scribe or monk, might be enhanced by a rustic, dark look which could be effected by heavy antiquing. You can also 'spot' antique, that is, by using heavier antiquing in the background and only a light film of antiquing to mellow the image. Even for projects that do not seem to call for antiquing, I have found that a very light antiquing can mellow and give depth to the images. A single colour, such as the Burnt Umber used for the antiquing process, can bind all the colours used in the work into a harmonious unity.

Some artists use a pre-antiquing medium or a matt picture varnish prior to antiquing. This will prevent any smudging or rubbing away of fine lines when the patina is applied. A patina is a mixture that helps move the oil paint that is applied in antiquing. You can obtain a commercially produced brand or mix your own with gum turpentine and linseed oil, three parts to one. The oil paint for most pieces is Burnt Umber (Paynes Grey can be used if the project is predominantly blue). Apply some patina to a soft cotton cloth and wipe a thin coat over the surface of the work; the initial coat will make control of the oil paint easier. Apply some more patina to the cloth, squeeze the oil paint onto the cloth and rub in gently with a circular motion. Allow to sit for 10 to 20 minutes, then wipe off any excess with a clean cloth until the desired effect is achieved. Dark and stubborn areas can be managed with a little fresh patina. Allow a good drying time before varnishing, that is, one to three days.

Varnishing

Before varnishing, remove all lint or dust with a tack cloth. Use a good satin polyurethane oil-based varnish to apply two to three coats (depending on how often the piece will be used) with a soft brush, using long, even strokes. Sand very lightly between coats.

Waxing

Waxing gives the final touch to something to which you have given so much time and attention. It will give a mellow glow and finish to the work. Apply a little beeswax furniture polish (not silicone) to 0000 steel wool and rub in with a gentle circular motion. Allow to stand for approximately 20 minutes and buff with a soft cloth. From time to time, revitalise the finish with a similar application.

EQUIPMENT NEEDED

Paints

The majority of paints that I have used for the projects in this book are Matisse Acrylic Flow Formula Colours, especially made for folk art.

I use Matisse paints because I enjoy mixing and creating my own colours and their pure pigments allow me to mix a number of colours together, and yet still retain quality and clarity.

Background Colours

Use folk art acrylic background colours. I have again found Matisse colours most satisfactory. Colours suggested in this book will be from the Matisse range. If you are using other brands, match up your colours with a Matisse Colour Chart.

Brushes

I have used a limited range of brushes for painting the projects in this book. You will need:
- round, acrylic or sable, Nos 00, 1, 2, 3
- flat, 7 mm (¼") long hair acrylic
- very fine liner brush
- varnishing brush, 25 mm (1") approximately
- background painting brush.

I suggest that you use the brushes as follows:
- Nos 00 and 1 round: for faces and fine decoration
- Nos 1, 2, 3, round: for blocking in shapes
- No 3 round: for floating
- 7 mm (¼") flat: for dry brushing.

MISCELLANEOUS EQUIPMENT

- stylus
- tracing paper
- transfer paper
- sandpaper (aluminium oxide 180)
- steel wool 0000
- patina
- Burnt Umber oil paint
- polyurethane satin varnish
- beeswax polish
- matt picture frame varnish or pre-antiquing medium
- carbon pencil
- palette
- crackle medium
- paper towel
- water container.

3

LORDS, LADIES, LISTS & LOVERS

✠

Courtly Life

in the

Middle Ages

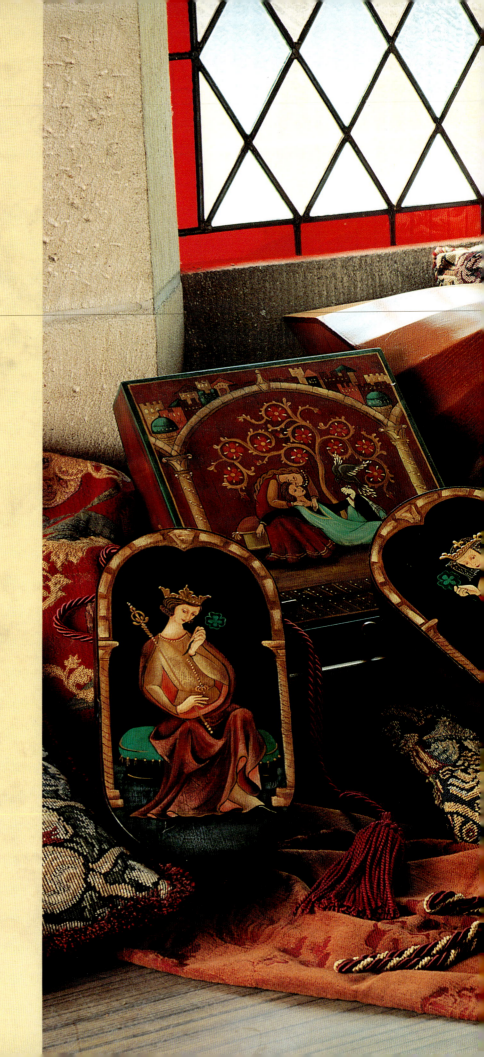

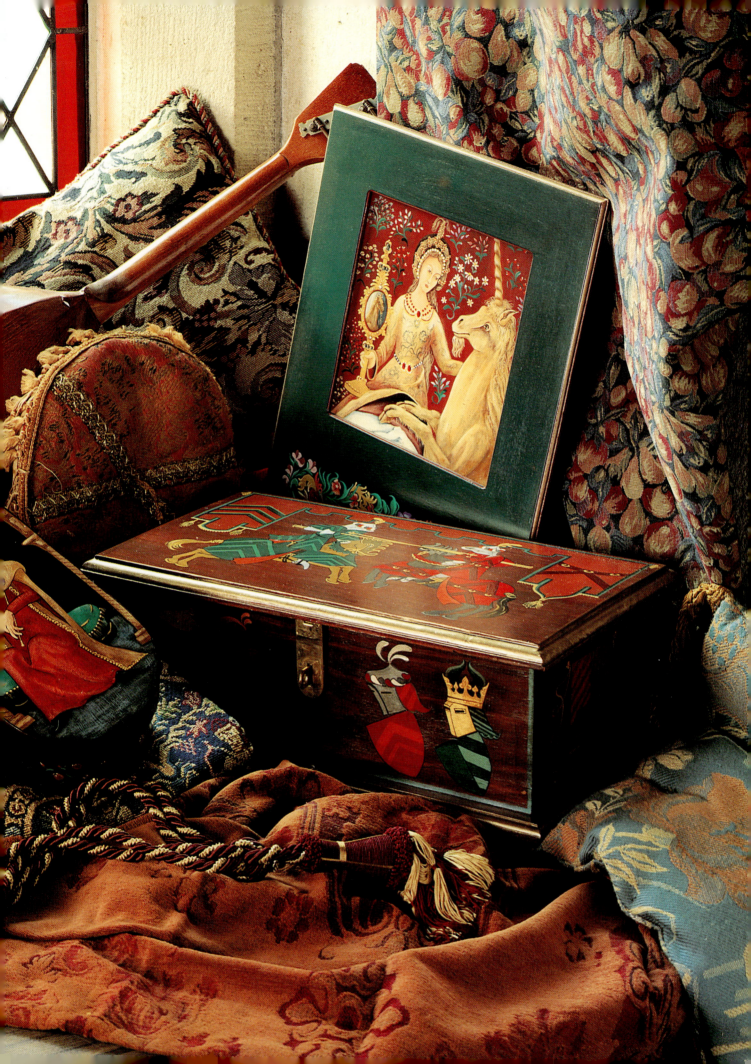

he first group of projects draws on the great interest that there has always been in the people and events of the court. Behind the serene and stylised portraits of King Edward and his Queen Isabella, lies all the drama of their marriage and its decline until Edward's death — a story of calculation and betrayal that repeats itself many times over in the course of the centuries.

Representations of deeds of chivalry, whether on the battlefield, in tournaments, or in defending ladies' honour, are abundant. They are both chronicles of history, in the way that they identify people and events, and testimony to the passions and aspirations of humans. So powerful are the images and the language of chivalry and armed combat, that the names of many of the knights who 'entered the lists' have remained as household names. Lancelot, the Black Prince, the Green Knight, Sir Galahad are just a few.

We ought not think of the women of the court as mere shadowy and decorative consorts of their menfolk. Behind the studied elegance of the way in which they are often depicted, lies another reality — that of well-educated, self-assured and competent managers. Because their men were often absent, responsibility for daily life fell on their shoulders. They raised children, supervised estates, directed farmers and servants, settled disputes and were even known to defend their property against attack. Since the economy of the Middle Ages was based largely on land, marriage among the upper class was as much a business contract as an expression of romantic love, although the narratives and poetry of the period are full of the latter. They also reveal the wit, sophistication and frankness of educated women, as is shown by this fragment from a twelfth century Middle Eastern text, in which a woman berates her lover who fell asleep on her:

> But if you are a lover, blush with shame;
> Sleep is unworthy of the lover's name.
> A man who sleeps before death's sleep I call
> A lover of himself, and that is all!
> You've no idea of love, and may your sleep
> Be like your ignorance, prolonged and deep!

The projects provided in this chapter are:

✠ *QUEEN ISABELLA*

✠ *KING EDWARD II*

✠ *JOUSTING KNIGHTS*

✠ *A KNIGHT AND HIS LADY*

✠ *LADY AND THE UNICORN*

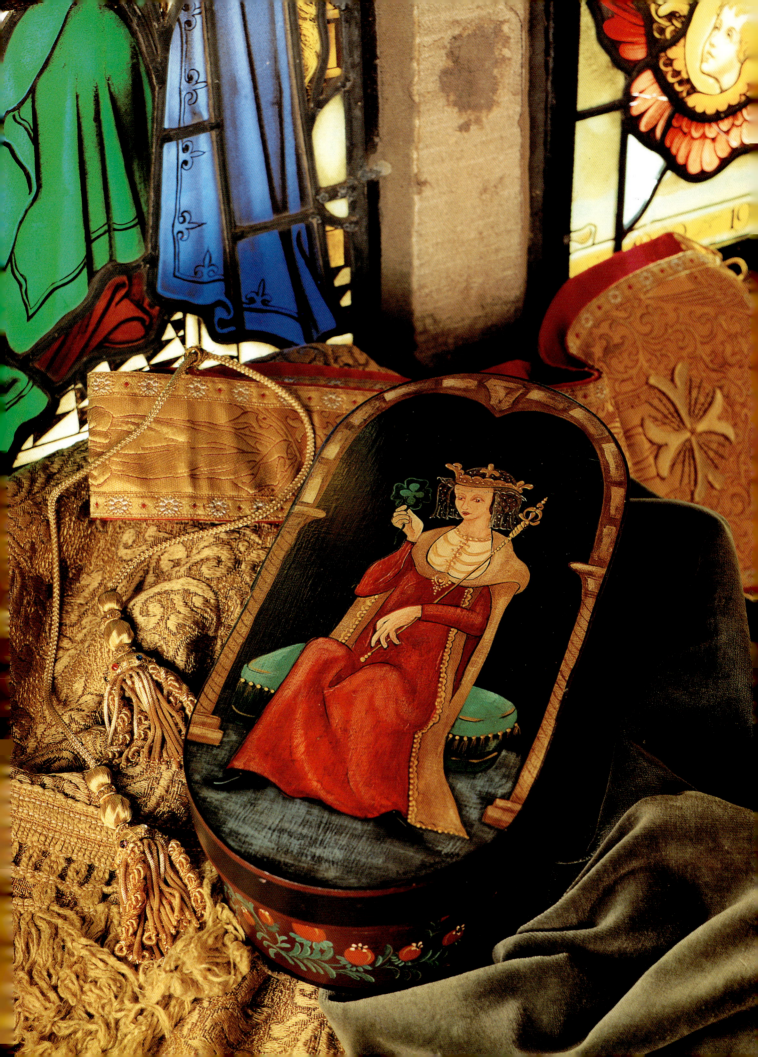

QUEEN ISABELLA

~

I brought hir to worship and she me to scorne,
I did hir reverence and she me velanye.
Quia amore langueo.

ANON.
13th century

QUEEN ISABELLA (1292-1358) was the daughter of Philip IV, 'Philip the Fair', of France, and Joan of Champagne, wife of Edward II of England (1308-27). Isabella was known as the 'she-wolf' of France.

In our day, people of western European tradition often react strongly to the practice of arranged marriages in other cultures. For the wealthy and the powerful, in Europe as elsewhere, in mediaeval times as today, alliance in marriage was seen as a powerful political strategy.

Early in the marriage of Edward and Isabella, Edward showed his preference for his male favourite, Piers Gaveston, on whom he lavished much of Isabella's jewellery. After Gaveston's death, Isabella and Edward did become closer and, in fact, produced four children. In 1324, Isabella took Roger Mortimer as her lover and in 1326, she conspired with Mortimer to depose Edward and have him imprisoned.

Degree of difficulty - 1

MATERIALS

Oval plywood box 330 mm x 160 mm (13" x 6½")
Background colours: Matisse Midnight Blue and Burgundy
Decorative colours: Raw Sienna, Titanium White, Phthalo Green, Metallic Gold, Burnt Umber, Midnight Blue, Vermilion, Naphthol Crimson, Black
Brushes: 7 mm (¼") flat, Nos 00, 1 and 3 round, a liner, background brush, varnish brush
Miscellaneous: crackle, stylus, sandpaper, patina, Burnt Umber oil paint, varnish and wax.

PREPARATION

With a 25 mm (1") background brush, paint the outside of the lid and the whole inside of the box in Burgundy. Paint the outside of the base in Midnight Blue. Allow drying time and then add a little crackle medium, particularly in areas where the image will not be, and on the skirt. When dry, paint on Midnight Blue in all areas other than the out-

side base. Paint the outside base Burgundy. Sand when dry. Trace the pattern and apply to the box.

PAINTING THE IMAGE

Dry brush Midnight Blue and White (3:1) across the floor area before commencing the figure painting.

1 Paint in the face and hands in flesh colour and then add the features (refer to Painting Faces and Hands in General Techniques, Chapter 2).

2 Block in the following shapes in the colours indicated (see Blocking, Chapter 2). The dress and cape can be a little textured — build up a few coats.

Hair: Burnt Umber
Yoke: White
Seat Top: Phthalo Green and White (2:1)
Seat Base: Phthalo Green and White (4:1)
Flower Edge: Phthalo Green and White (4:1)
Flower Centre: Phthalo Green and White (2:1)
Dress: Napthol Crimson
Cape: Raw Sienna and White (3:1)
Columns and Arch: Raw Sienna and White (3:1)

3 Crosshatch lines on the hair in Midnight Blue.

4 Paint the veil in a watery White mixture and then add a little more White to the mixture. With a liner brush, outline and paint tiny dots over the veil.

5 Mix Raw Sienna and White (3:1) and dry brush (refer to Dry Brushing in General Techniques, Chapter 2) using a 7 mm (¼") flat brush lightly down over the cape.

6 Dry brush the same Raw Sienna and White (3:1) mixture down the columns and across the stonework over the arch.

7 Outline the bricks and paint on the lines down the columns in Burnt Umber.

8 Trace on the folds of the dress. Load a 7 mm (¼") flat brush with Vermilion and dry brush the highlights down over the dress.

9 Paint the following in Metallic Gold:
 • the scallops down the edge of the cape
 • lines on the yoke
 • the sceptre rod

• the crown
• lines on seat
• the tassels on the seat.

10 Decorate the crown, sceptre, yoke and edge of cape with textured commas and dots (made with a stylus) as shown in the picture and pattern.

11 Outline the image using a fine liner brush in Midnight Blue.

12 Paint a Burgundy line, 4 mm, ($^1/_8$") around (i) the edge of the lid of the box (ii) the top edge and lower edge of the side of the lid and (iii) the top and lower edge of the sides of the box.

13 Trace the flowers onto the front end of the base of the box and paint as follows:
• the round flower shape and buds are painted in Vermilion
• add a White daisy shape to the top of each flower
• paint a few Black strokes in the centre of each daisy
• add a Metallic Gold dot to the centre and a comma down the side of each flower
• paint the leaves in Phthalo Green and White (2:1), using textured commas that are also loaded with a lighter shade on the tip.

14 In the inside lid, you could paint the leaf shape or the flower pattern from the side of the box, and/or the verse.

15 Antique, varnish and wax.

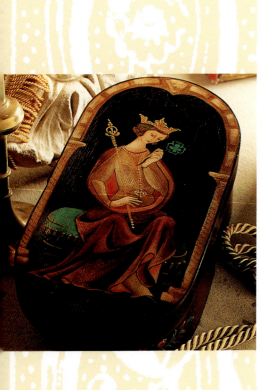

KING EDWARD II
~

Then, happy low, lie down!
Uneasy lies the head that wears a crown.

SHAKESPEARE,
Henry IV, Part 2

EDWARD IS DESCRIBED as strong and handsome, a dashing horseman, a keen warrior — but not a good leader in battle. He was pursued in 1326 by his own wife, Queen Isabella, captured in Wales and imprisoned at Berkeley Castle. Legend says that he escaped and wandered the continent as a hermit. The more likely explanation is that he was mur-

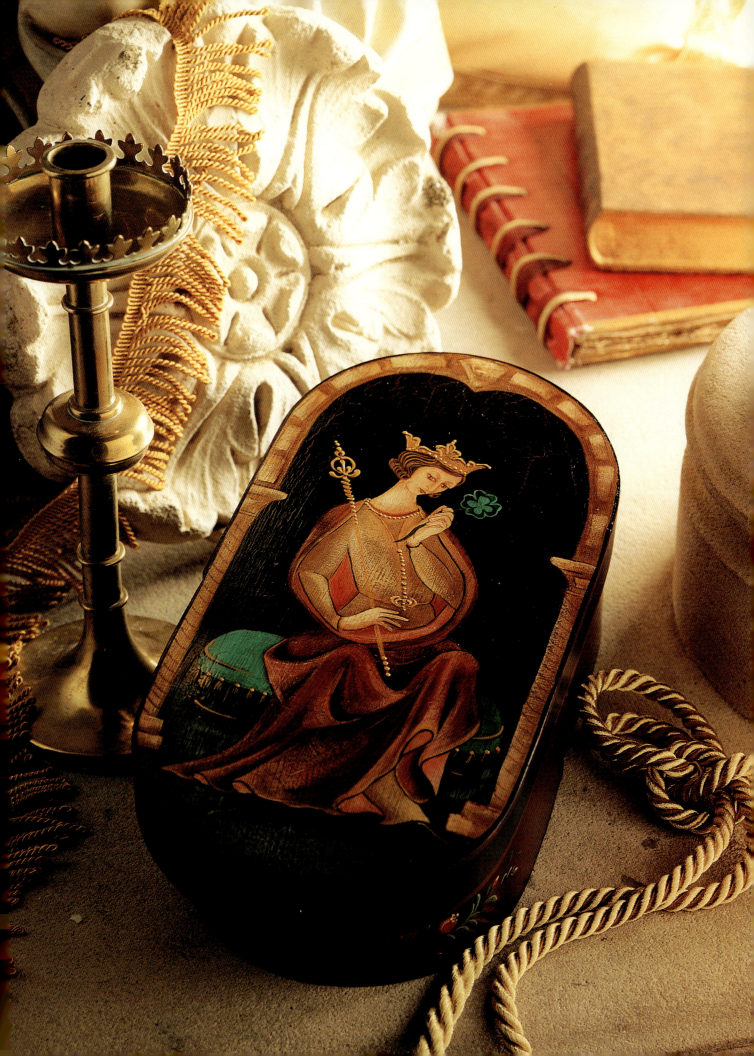

dered at Berkeley Castle in 1327. One chronicle describes him as 'the first Plantagenet king of England to be deposed, and one of the least competent of his line'.

Degree of difficulty - 1

MATERIALS

Long oval plywood box 330 mm x 160 mm (13" x 6½")
Background colours: Midnight Blue, Burgundy
Decorative colours: Raw Sienna, Titanium White, Phthalo Green, Midnight Blue, Burnt Umber, Vermilion, Terracotta, Metallic Gold, Burgundy, Naphthol Crimson
Brushes: Nos 00, 1, 3, round, a liner, 7 mm (¼") flat, background and varnish brushes
Miscellaneous: crackle medium, sandpaper, patina, Burnt Umber oil paint, varnish, stylus, wax.

PREPARATION

(as for Queen Isabella)

PAINTING THE IMAGE

Dry brush with Midnight Blue and White (3:1) before commencing the figure painting.

1 Paint in the face and hands in flesh colour and then add the features (See Painting Faces and Hands, General Techniques, Chapter 2).

2 Block in the following shapes in the colours indicated (See General Techniques). The garments can be painted with a little extra texture — apply 2-3 coats.

Hair: Burnt Umber
Undergarment: Raw Sienna
Lining of Cloak: Vermilion
Cape: Burgundy and Crimson (2:1)
Seat Base: Phthalo Green and White (4:1)
Seat Top: Phthalo Green and White (2:1)
Flower Centre: Phthalo Green and White (2:1)
Edge of Flower: Phthalo Green and White (4:1)
Columns and Arch: Raw Sienna and White (3:1)

3 Using a liner brush, paint fine Raw Sienna and White (3:1) lines on the hair.

4 Mix Vermilion and White (3:1) and, using a flat 7 mm (¼") brush, dry brush highlights onto the lining of the cape around the hem and

where the lining can be seen curving up from the right-hand side.

5 Mix Raw Sienna and White (3:1) and dry brush (See General Techniques, Chapter 2) highlights onto the undergarment.

6 Trace on the folds of the cape. Mix Terracotta and White (3:1) and following the colour picture, dry brush highlights onto the cape. Brush on the fold, keeping in mind the movement and line of the folds and moving your brush in the direction they take. Be sure to leave the depth of the folds dark. You can even add a little Burnt Umber into the dark of the folds to make them appear deeper.

7 Add a little more White to the Terracotta mixture and brush on few lighter highlights here and there; this will create a little more depth.

8 Dry brush a mixture of Raw Sienna and White (2:1) down the columns and across the stonework, concentrating on the left side of columns and bricks with a lighter tone.

9 Outline the bricks and paint the lines down the columns with Burnt Umber.

10 Paint the following in Metallic Gold:
 • the crown
 • the sceptre rod
 • lines on seat
 • tassels
 • float an edge around the cape neck, hemline of cape, down the
 centre of the bodice and the end of the sleeve.

Decorate the crown, sceptre, seat and bodice in textured commas and dots (made with a stylus) as shown in the picture and pattern.

11 Outline the image in Midnight Blue.

12 Paint a Burgundy line, 4 mm (1⁄8") around (i) the edge of the tip of the box (ii) the top and bottom edge of the side of the lid (iii) the top and lower edge of the sides of the box.

13 In the inside lid you could paint the leaf shape or the flower pattern from the side of the box and/or the verse.

14 Refer to Queen Isabella project for painting of the flowers on the side of the box.

15 Antique, varnish and wax.

KNIGHTS JOUSTING
~

Who so mygth take ordere of chivalry moste
In evry wise be a gode Knught.

MERLIN C.1450

CONTESTANTS FROM A fifteenth century joust. They wear full tilting helmets and plate armour, developed for protection against the couched lance, In a sporting joust, their weapons would have been blunted. Elaborate heraldry identified them to spectators and to other competitors in the joust.

This is a very straightforward design requiring only flat painting and outlining. It is a delightful project for a young person to paint. The flags around the side could be useful as a small design for the inside of boxes.

Degree of Difficulty - 2

MATERIALS

Large document box 500 mm x 280 mm (20" x 11")
Background paint: Pimento, Liquitex Clear Stain
Decorative colours: Spruce, Silver, Titanium White, White Pearl, Vermilion, Black, Raw Sienna, Gold Light, Naphthol Crimson, Burnt Umber, Alizarin Crimson
Brushes: liner, Nos 1 & 3 round, varnish brush
Miscellaneous: patina, Burnt Sienna oil paint, varnish and wax.

PREPARATION

Because the box I have painted on is solid pine, I chose to stain it so that the grain would still be apparent (refer to Staining in General Techniques, Chapter 2). I used a mixture of Liquitex Clear Stain, Pimento Background Paint and Matisse Burnt Umber Acrylic Paint (2:2:1) and applied it with a cloth, working down the grain. If your timber piece is craftwood (custom wood) paint in a colour of your choice; I would suggest a dark colour so that the bright colours of the image show to their full advantage. Sand when dry.

PAINTING THE IMAGE

The entire design is painted in flat colour and then outlined. Use the colour picture as a guide. Block in the following shapes in the colours indicated:

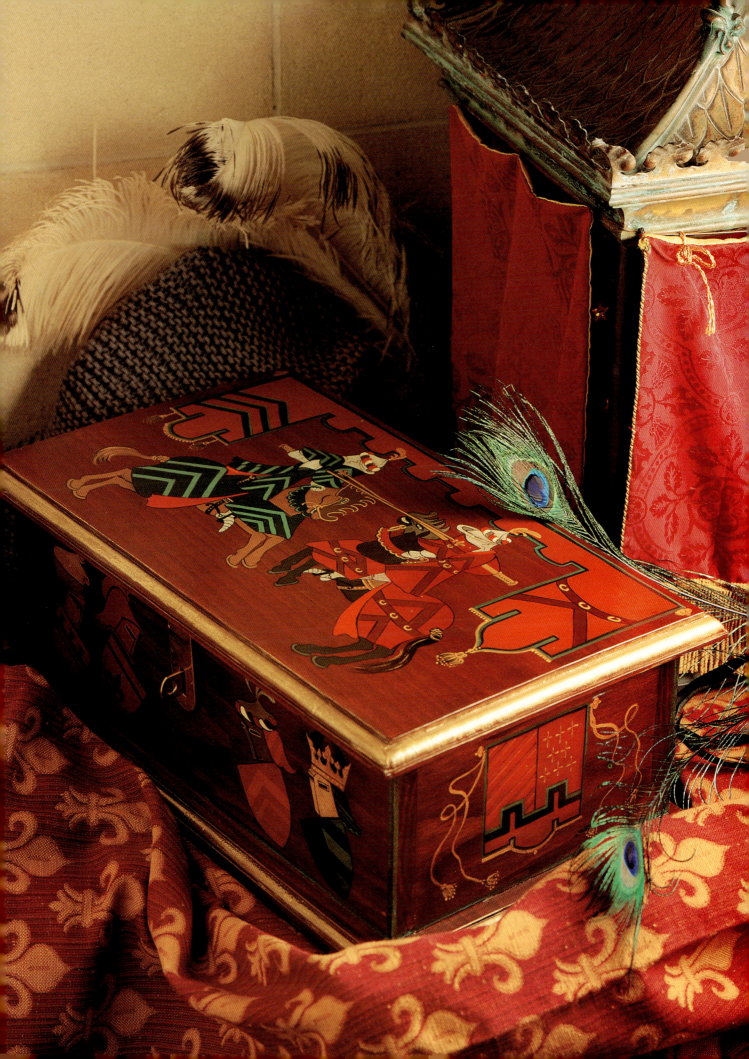

Figure on Left

Horse: Raw Sienna and Gold Light (3:1)

Helmet on Horse: Raw Sienna, Black and Gold Light (3:1:1)

Knight's Body Armour: Silver and White (1:1)

Knight's Tunic and Shield: Spruce and White Pearl (3:1)

Horse's Blanket: Spruce and White Pearl (3:1)

Stripes on Spruce Shapes: Spruce, White Pearl and White (3:1:1)

Turnback on Blanket & Tunic: Vermilion

Saddle and Strap: Black and Raw Sienna (3:1)

Lance: Gold Light

Decoration Around Helmet: White, Black and Silver (1:1), Vermilion

Horse's Eye: White with a Black iris and outline, and White centre flash

Figure on Right

Horse: Black and Silver (4:1)

Horse's Helmet: Black and Silver (2:1)

Knight's Body Armour: Silver and White (1:1)

Horse's Blanket: Naphthol Crimson

Knight's Tunic and Shield: Naphthol Crimson

Stripes on Blanket & Tunic: Burnt Umber and Alizarin Crimson (1:1)

Foldback on Blanket: Vermilion

Fold at Knight's Neck: Vermilion

Saddle: Raw Sienna and White (4:1)

Decoration Around Knight's Head: White, Black and Silver (1:1), and Vermilion

Lance: Gold Light

Horse's Teeth: Warm White

Horse's Eye: Warm White with a Black iris and outline, and White centre flash

Add the decoration as follows:

1 Paint the following in Gold Light:
 • three textured commas on the end of each lance
 • outline the helmet of the horse on the left
 • the gold rings on the horse's helmet
 • gold comma on the blanket and tunic on right
 • gold lines and dots on lower saddles.

2 Painting the banner across the top of the box:
 • give the whole surface two coats of Terracotta
 • paint the stripes on the left in Spruce and White paint (4:1)
 • add a Spruce and White Pearl (1:1) line on top
 • add a Spruce line underneath the original stripe

- paint the stripes on the right in a mixture of Burnt Umber and Alizarin Crimson (1:1)
- add a Vermilion line on top of the curved stripe and a Vermilion line under the lower stripe. Paint a Spruce line on the alternate side of the main stripes
- paint a Spruce and White Pearl (4:1) line around the entire banner, followed by a darker Spruce and White Pearl line (2:1)
- decorate the edges of each banner; the knobs either end and the curved shapes on the stripes on the right are painted in Gold Light
- the tassels are painted in Spruce and White Pearl lines, overlaid with Gold Light lines and little dots along the bottom.

3 Paint the decoration on the side of box:
The colours used in the decorations are basically the same as on the top of the box. Use the colour picture as a reference.

4 Banners at each end of the box:

Basic colours: Terracotta base, White Pearl & Spruce (1:3)
Fleur de Lys and Lion: Cadmium Red
Division Line: Cadmium Red
Cords and Line Work: Gold Light

5 Helmets and Shields (left to right):

No. 1: Metallic Gold, Spruce and White Pearl (3:1), Cadmium Red, Black
No. 2: Copper, Spruce and White Pearl (3:1), Terracotta
No. 3: Silver, Silver and Black (1:1), White, Naphthol Crimson, Vermilion
No. 4: Gold Light, Spruce and White Pearl (4:1), Spruce and White Pearl (1:1).

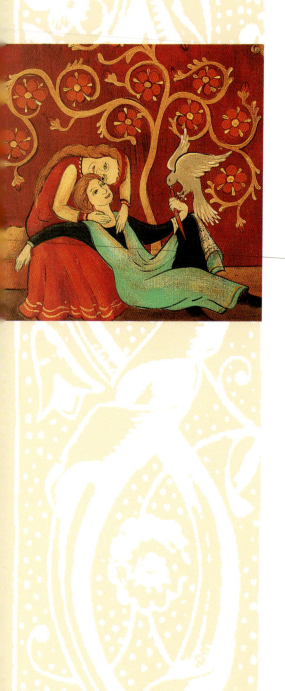

KNIGHT AND HIS LADY

~

For thy sweet love remembered
Such joy brings
That then I scorn
To change my state with Kings

SHAKESPEARE
Sonnet 29

NO LESS THAN for ourselves, love and romance fascinated mediaeval men and women, from lords and ladies of the court, to the common folk. The minnesingers, who wrote and sang of love and lovers, were frequently depicted by artists. The charming couple that appears in this project is typical of many painted in fourteenth century German manuscripts, and is now housed in Heidelburg. This painting shows Konrad von Altetetten, a German minnesinger, in the arms of his beloved beneath a briar tree. The rose and briar symbolise the entwined beauty and thorny trials of love.

Degree of Difficulty - 3

MATERIALS

An upright secretaire 360 mm x 270 mm (14½" x 11")
Background paint: Midnight Blue and Pimento
Decorative colours: Raw Sienna, Titanium White, Burnt Sienna, Burnt Umber, Cadmium Yellow, Raw Sienna, Metallic Gold, Terracotta, Phthalo Green, Black, Naphthol Crimson, Vermilion, Burgundy
Brushes: flat 7 mm (¼"), Nos 00, 1 & 3 round, a liner
Miscellaneous: stylus, patina, Burnt Umber oil paint, varnish, wax, background brush.

PREPARATION

With a 25mm (1") background brush, paint all surfaces with one coat of Midnight Blue. When dry paint on a coat of Pimento. Sand well when dry distressing the surface 'here and there'.

PAINTING THE IMAGE

1 Paint the faces and hands in flesh colour and add the features (refer to Painting Faces and Hands in General Techniques, Chapter 2). Note that the man's left hand has a glove on it.

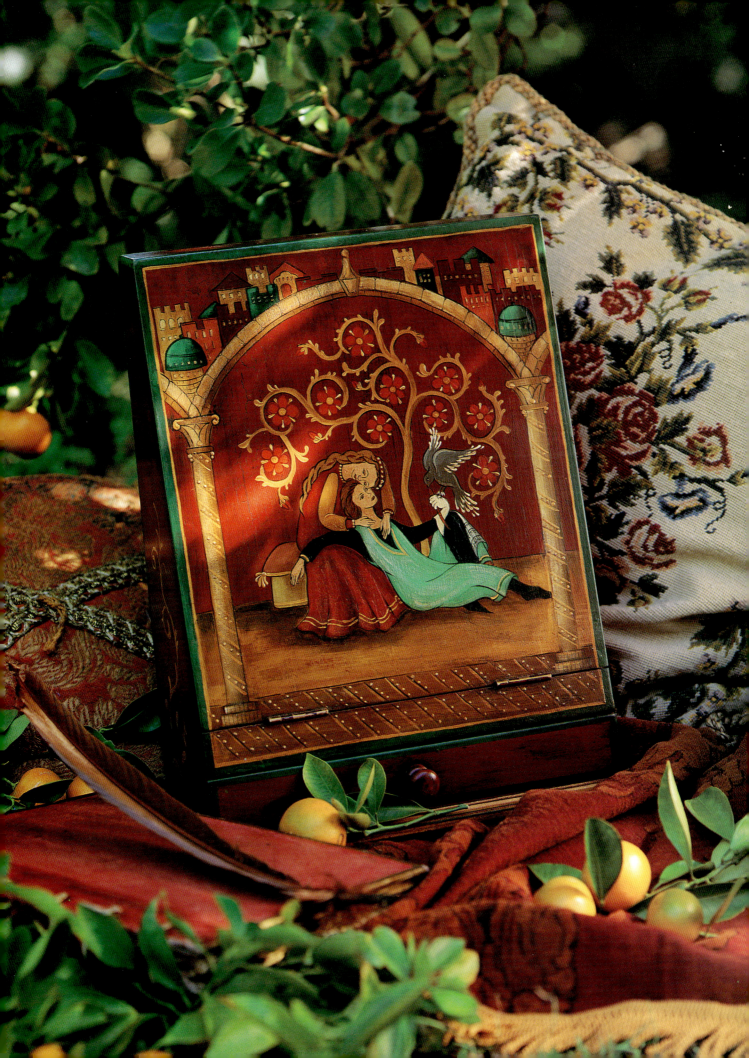

2 The buildings are painted in a variety of colours; refer to the colour picture and block in accordingly.

Dark red: Naphthol Crimson
Green: Phthalo Green
Orange: Terracotta
Yellow: Cadmium Yellow and Raw Sienna (3:1)
Ochre: Raw Sienna and White (3:1)

Add a little White to each colour and lightly dry brush (refer to Dry Brushing in General Techniques, Chapter 2).

3 Mix Raw Sienna and White (2:1) and paint the branches of the tree. Paint the flowers in Terracotta and White (3:1) with Cadmium Yellow and Raw Sienna (3:1) with a textured comma between each petal. Use the Raw Sienna and White mixture (2:1) to paint the textured commas on the tree branches. Outline the branches 'here and there' with Burnt Umber.

4 Block in the floor in Raw Sienna and White (3:1). Make a wash of Burnt Umber and Midnight Blue and create a shadow by brushing around the lower edge of the seat and figures. Allow to dry and then paint a thin Metallic Gold wash over the whole floor. Paint the lines on the lower part of the floor in Metallic Gold, with a fine Burnt Umber line along the right side. Add Gold dots down each Burnt Umber line.

5 Block in the following shapes in the colours indicated:

Columns and Arches: Raw Sienna and White (3:1)
Seat Top: Raw Sienna, Terracotta and White (1:1:1)
Seat Base: Terracotta and White (2:1)
Hair: Burnt Sienna
Lady's Sleeves: Raw Sienna and White (1:1)
Dress: Naphthol Crimson, 2-3 coats
Undergarment (man): Phthalo Green
Man's Overgarment: Phthalo Green and White (2:1)
Glove: White
Lining of Man's Overgarment (foldback): Black and White (1:3)
Bird: Black and White (1:3)
Shoes: Black
Stick in Man's Hand: Terracotta

6 Dry brush (refer to Dry Brushing in General Painting Techniques, Chapter 2) a mixture of Raw Sienna and White (2:1) down the columns and across the stonework on the arches. Mix in a little more White and add a lighter tone, by dry brushing down the left side of the columns

and the left edge of each stone. Lightly outline each piece of stone in Burnt Umber and then the edges of the archway and columns and the centre keystone at the top in Midnight Blue. Paint fine Burnt Umber lines across the columns. Using a stylus, add little Metallic Gold dots to each line across the column. Add Metallic Gold curls to the capitals on top of the columns and a line down the side of the keystone.

7 Add a little White to the base colours of the seat and dry brush highlights on the left side.

8 Mix a lighter shade of the base colour of the Lady's sleeve and dry brush on highlights down the sleeves.

9 Pencil on the folds of the lady's dress and dry brush Vermilion on top of the folds and down the back of the bodice.

10 Mix Phthalo Green and White (1:1) and dry brush down the man's overgarment.

11 Paint White highlights onto the grey lining of the man's overgarment and, using a liner brush, paint on the decoration in Black.

12 Paint on fine Burnt Umber lines to define the hair of both figures.

13 Paint White textured commas as feathers on the bird.

14 Paint Metallic Gold dots around the neck and sleeves of the lady's dress, the gold lines around the neck of the man's garment and the hemlines of both garments.

15 Outline the seat, both figures and the bird, with fine Midnight Blue lines.

16 Paint a 7 mm (¼") Phthalo Green and White (3:1) line around the edge of the painting, and also around the drawer. Paint a fine Gold line inside all the Green lines.

17 Rub Metallic Gold around the edge of the base.

Inside the Box: the Scroll
 • trace the scroll on the inside writing surface
 • paint in Raw Sienna, creating an opaque finish
 • Add White to the Raw Sienna and dry brush over the scroll
 • Keep adding White to Raw Sienna and each time you paint on a lighter shade be sure to leave some of the darker colour below
 • dry brush on a little Burnt Umber under the top roll
 • paint the knobs in Burgundy

- outline scroll in Burnt Umber
- paint the tassel and cord in Burnt Umber and over paint in Metallic Gold
- paint Metallic Gold lines and textured commas down the sides of scroll and add decoration to knobs
- lightly sand, distressing the surface in some parts
- write verse in a thin mix of Burnt Umber with a liner brush
- paint a 7 mm ($\frac{1}{4}$") Phthalo Green and White (3:1) line around the edge of writing surface
- antique, varnish and wax the whole piece.

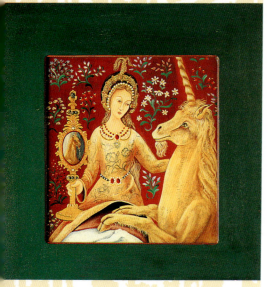

LADY AND THE UNICORN
~

For whoso loketh in that mirrour,
There may nothing ben his socour
That he ne shall there sen somthing
That shall him lede into loving.

THE ROMANCE OF THE ROSE
Trans. Chaucer

THIS PAINTING IS an adaptation of one of the glorious 15th century Lady with the Unicorn tapestries that are housed in the Cluny Museum in Paris.

There are six tapestries in the series. Five of the six represent the senses, taste, sight, hearing, smell and touch. The sixth tapestry is called A Mon Seul Désir (to the only one I love). The one I have adapted is the 'sense of sight', featuring the image of the beautiful unicorn so often portrayed in mediaeval art.

This series of tapestries has provided a wonderful source of inspiration, enjoyment and direction in my work.

Degree of Difficulty - 4

MATERIALS

Rectangular Frame 500 mm x 360 mm (20" x 14½")
(image measures 240 mm x 240 mm [9½" x 9½"])
Background colours: Midnight Blue, Pimento
Decorative colours: Titanium White, Black, Terracotta, Vermilion,

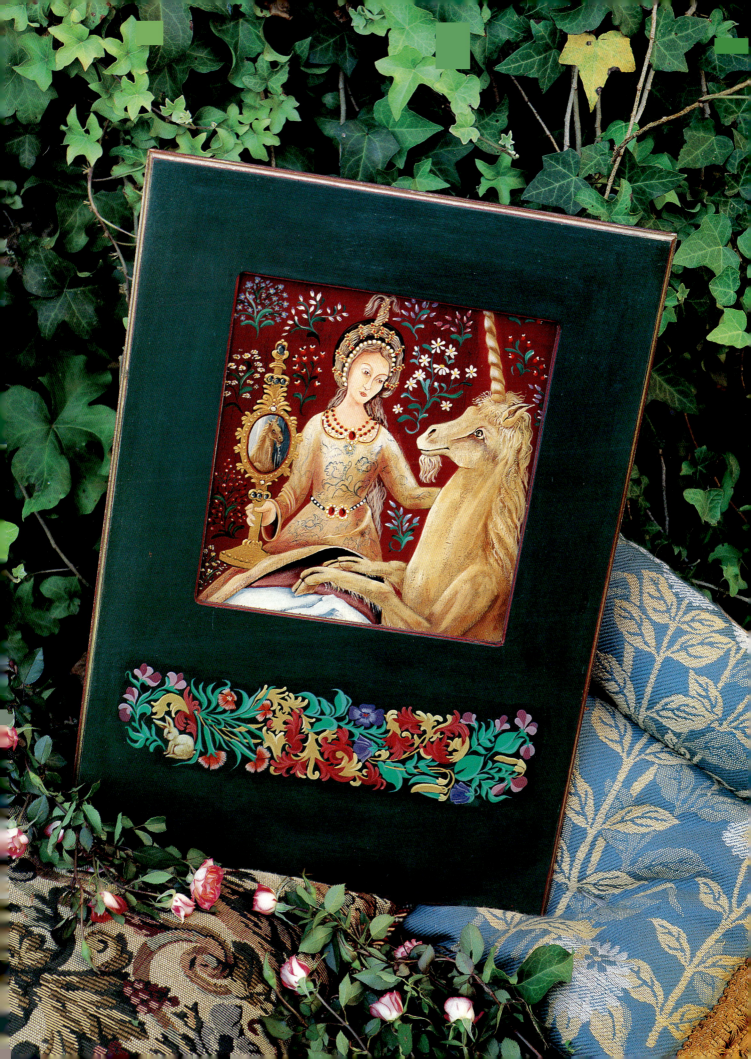

Antique White, Raw Sienna, Burnt Sienna, Cadmium Red, Midnight Blue, Metallic Gold, Gold Light, Yellow Oxide, Spruce, Alizarin Crimson, Burnt Umber, White Pearl, Phthalo Green
Flowers around Figure: Phthalo Green, Ultramarine Blue, Titanium White, Cadmium Yellow, Vermilion, Naphthol Crimson
Brushes: 00, 0, 1, 3 round, 7 mm (¼") flat, liner
Miscellaneous: Burnt Umber oil paint, patina, varnish, stylus.

PREPARATION

Board:
Paint with one coat of Midnight Blue, followed by one coat of Pimento Base Coat, and sand when dry.

Frame:
Paint with one coat of Pimento background paint, followed by a coat of Spruce Flow Medium paint with a touch of White added. Sand when dry.

PAINTING THE IMAGE

1 Trace on the pattern.

2 Paint the face and hands (refer to Painting Faces and Hands in General Techniques, Chapter 2).

3 Block in the following shapes in the colours indicated:

Lady's Underskirt: Midnight Blue and White (2:1)
Lining of Dress: Alizarin Crimson, Burnt Umber (1:1)
Inside Sleeve: as for the lining
Dress: Raw Sienna with a touch of White
Dark Bands on Hair: Burnt Umber
Unicorn: Raw Sienna and White (5:1)
Glass on Mirror: Midnight Blue and White (5:1)
Mirror Stand: one coat of Yellow Oxide, followed by a coat of Metallic Gold

4 Retrace the details of the pattern, except for the brocade on the dress.

5 There is quite a lot of dry brushing in this project (refer to Dry Brushing in General Technique, Chapter 2).

6 Continue to add White to the underskirt colour (Midnight Blue and White) and dry brush across the surface, building up highlights, while still leaving some of the deeper tone either side of the centre fold.

7 Add a little Vermilion and White to the dress lining colour (Alizarin Crimson and Burnt Umber) and dry brush a highlight along the lower edge of the lining of the sleeve.

8 Continue to add White to Raw Sienna as you gradually build up layers of highlights on the dress. Concentrate around the shoulder line of the front of the bodice, and the top of the turnback of the skirt.

9 The split of each hoof, the mouth, the nostril and inside the ear of the unicorn is painted in flat Burnt Umber.

10 Using the same colour and technique as for the bodice of the dress, add highlights to the unicorn. You will need to build up about three or four shades of the colour, concentrating on the left side.

11 Paint the mane in a similar way as the body by running different tones of the colour down in a wavy movement. The hair around the bottom of the horn, under the chin and front legs, can be painted with a liner brush.

12 Dry brush a little Burnt Umber paint down under the eye and at the back of the cheek.

13 Paint the outline of the eye and the line that runs from the eye down towards the mouth in Burnt Umber.

14 Paint the iris in Burnt Umber and the rest of the eyeball in Antique White.

15 Paint a black pupil in the centre of the iris.

16 Paint a Raw Sienna and White (1:1) circle around the pupil and add an Antique White dot on the right-hand side of the pupil.

17 Be sure that the eyelid is highlighted.

18 Outline the edges of the ear in Burnt Umber.

19 Tidy up by repainting areas such as the mouth, nostril, the split in each hoof.

20 Mix Burnt Umber, Raw Sienna and White (1:2:1) and lightly brush a shadow on the bottom edge of each ring of the horn.

21 Brush a highlight down the left side of each ring of the horn using Raw Sienna and White (1:2).

22 Trace on the pattern on the dress. Make a wash with Midnight Blue and White (2:1) and lightly, with a very fluid hand movement and using a liner brush, paint on the lines of the brocade.

23 Using a liner brush and a mixture of Burnt Umber and White, paint in the fine strands of the lady's hair around the head and face, the top knot down either side of the neck and under the left arm.

24 Mark on where the hair decorations will be painted. Each little flower shape is painted by applying a circle of little Gold Light dots with a stylus, and adding a Cadmium Red dot to the centre. Apply a Gold and Red dot alternately up through the top knot.

25 Paint a row of dots in White Pearl around the hair line. Outline each in Gold Light.

26 The two top rows of beads around the neck are painted in Cadmium Red and outlined in Gold Light, with a Midnight Blue line added on the right side of each bead and in between each bead.

27 The third row of beads are White Pearl, outlined in Gold Light, with a similar treatment in Midnight Blue as above.

28 The large red stone in the front of the neck piece is painted in Cadmium Red, surrounded by a row of White Pearl, with two drop pearls in the front all outlined in Gold Light and an occasional touch of Midnight Blue.

29 Paint the belt in Midnight Blue; add White Pearl dots along it and paint the two centre jewels in a similar manner to the central jewel on the neck piece.

30 Paint a Cadmium Red line and a Gold Light line round the neck-line.

31 Outline the hand in Burnt Sienna.

32 Mix Midnight Blue and White (1:4) and starting on the left side of the glass with the mirror, blend across the surface, gradually adding more Midnight Blue.

33 Paint in the unicorn in Raw Sienna. Add White and then dry brush on a few highlights. With a liner brush, paint strokes down the back of the neck to represent the mane.

34 Paint the nostril, mouth, eye and inside the ear in Burnt Umber.

35 Add a dot of White to the eye.

36 Paint a few White vertical lines across the image to represent reflection across the glass.

37 Paint a Burnt Sienna line around the edge of the glass, followed by a Midnight Blue line.

38 The jewels on the mirror are painted in Midnight Blue and White, with a White highlight on the left side of each.

39 The decoration around the edge of the mirror is painted with Metallic Gold textured commas. There is a row of dots around the oval shape and also around the base. There is a White Pearl dot at the top and bottom of the oval.

40 Outline the mirror in Midnight Blue.

41 Refer to 'Painting Field Flowers' in General Techniques, Chapter 2, for the painting of the flowers around the figure.

42 Lightly antique, wax and varnish.

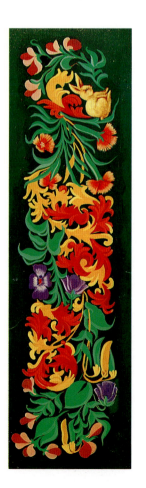

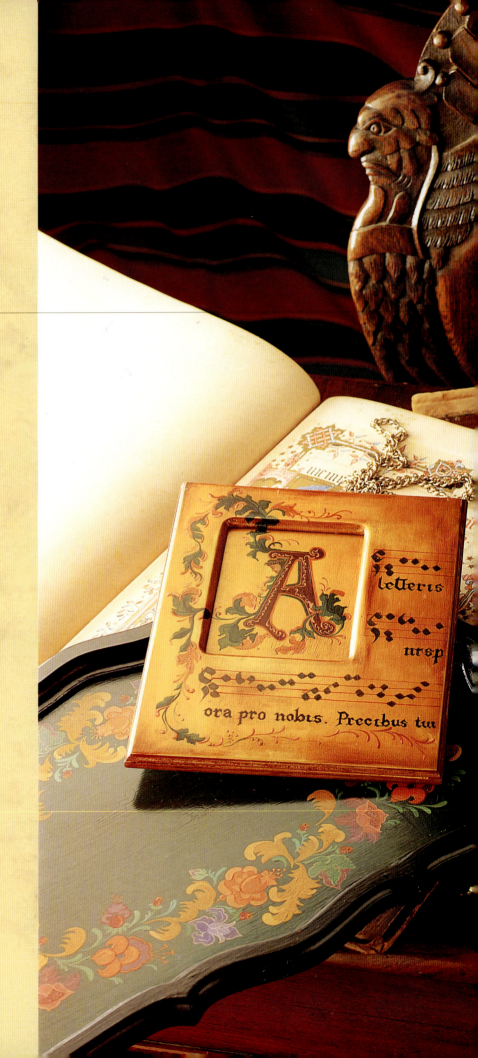

4

MONKS, MANU- SCRIPTS, & MOTIFS

Documents of the

Middle Ages

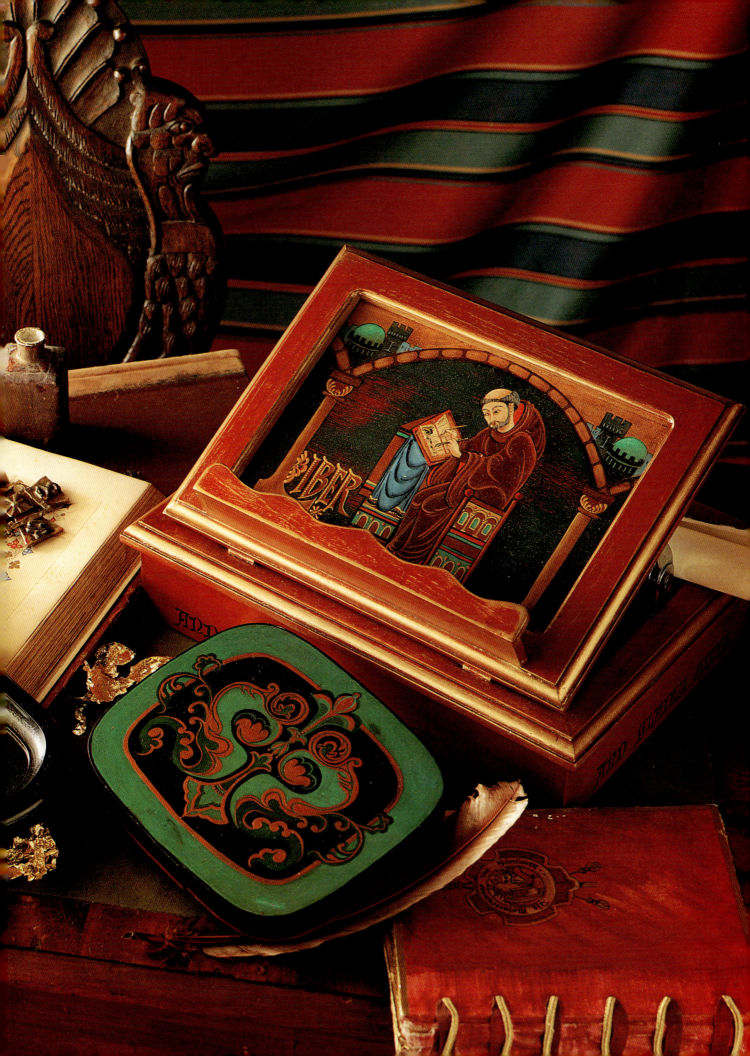

Before the invention of the printing press, monasteries accepted a large share of responsibility for producing books and the scriptorium, or writing room, held a very important academic function. One monk would dictate to a number of scribes who copied down, more or less faithfully, (according to personal intelligence, interest or whim) the text, which was generally of a biblical or religious nature.

The work of the scribes was embellished by the artistic and calligraphic skills of the illuminators. If a book was of particular value, the copying would be done on vellum or parchment. Colours were rich and luminous with much use of gold, and the text began with a large decorative capital.

More manuscripts survive from the Middle Ages than any other artefacts. Manuscripts were written all across Europe at all times during a period of about 1500 years, between the late Roman Empire and the High Renaissance. Until the eleventh or twelfth century, most books were produced by monks, although from that time on, because of demand, secular scribes began to be employed. Eventually secular workshops were established to supply universities and private collectors.

The projects provided in this chapter are:

✠ A SCRIBE
✠ ILLUMINATED FLOWERS
✠ ILLUMINATED LETTER
✠ MEDIAEVAL DESIGN

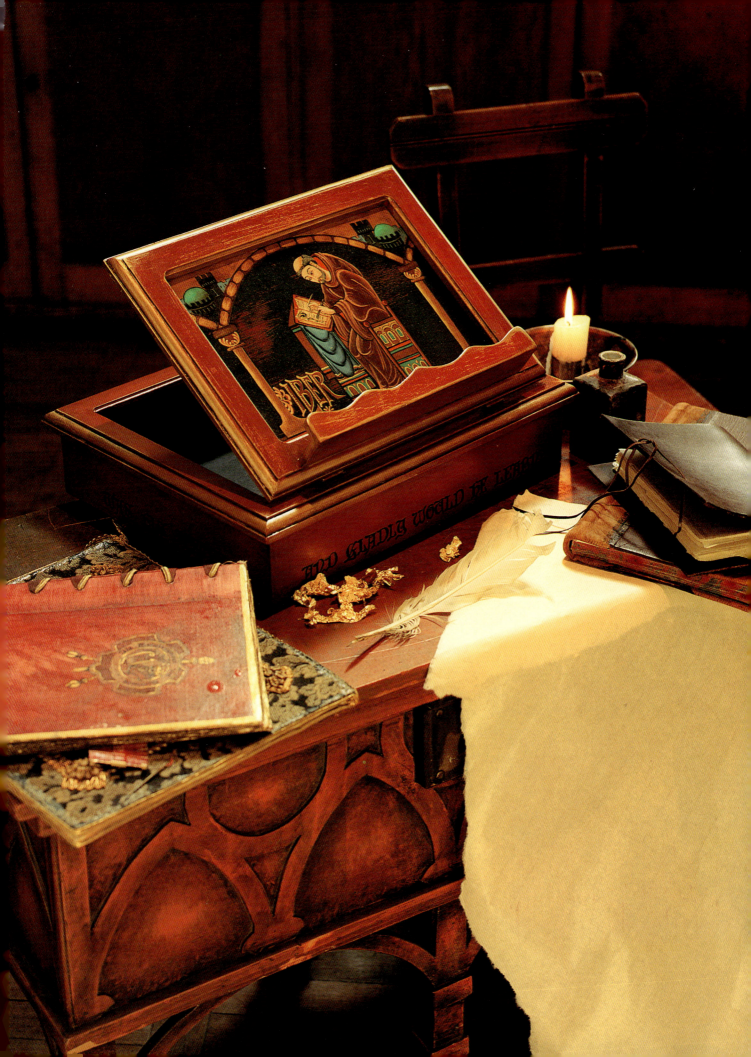

SCRIBE
~

*Sownynge in moral virtue was his speche
And gladly would he learn and gladly teche*

*His only care was study and indeed.
He never spoke a word more than was need
Formal at that, respectful in the extreme,
Short to the point and lofty in his theme
The thought of moral virtue filled his speech
And he would gladly learn and gladly teach.*

GEOFFREY CHAUCER,
Prologue to *The Canterbury Tales*

IT WAS THE WORK of the scribe to laboriously copy down the text of a book, usually of a biblical nature, onto parchment. The scribe in this project, which is based upon an illustration from a late 12th century German manuscript, is identified as the monk Eadwine, writing at his desk and carefully copying, using a quill and an ink horn.

Degree of Difficulty - 2

MATERIALS

A rectangular box or lectern box, as in the project. The image measures approximately 300 mm x 220 mm (12" x 8¾").
Background paint: Pimento, Turquoise
Decorative colours: Spruce, Burgundy, Naphthol Crimson, Vermilion, Gold Light, Terracotta, Raw Sienna, Midnight Blue, Burnt Sienna, Antique White, Copper, Phthalo Blue, Phthalo Green
Brushes: Nos 00 and 3 round, liner
Miscellaneous: stylus, patina, Burnt Umber oil paint, varnish, wax, crackle medium.

PREPARATION

To the board on which the image is to be painted, give one coat of Pimento and allow to dry before adding some crackle medium. When dry, follow with a coat of Turquoise. Sand well, distressing some areas.

The Lectern

I have painted the surface with a coat of Metallic Gold, followed by a coat of Pimento, and then distressed it quite heavily when dry.

PAINTING THE IMAGE

1 Paint the area behind the buildings above the archway in Raw Sienna and White (3:1) and the foreground across the bottom of the painting in Spruce.

2 Paint the whole head (hair can be painted on later) and hands in flesh colour (refer to Painting Faces and Hands in General Techniques, Chapter 2).

3 Desk and seat: Raw Sienna, Terracotta and White (2:2:1)
The decoration is in
- Green: Spruce and White (2:1)
- Orange: Vermilion
- Gold: Gold Light and White (2:1)
- Navy: Midnight Blue
- Outlines: all in Midnight Blue.

4 Paint the drape that hangs on the desk in Phthalo Blue and White (3:1) (retrace pattern) and then float side loads of Midnight Blue (see Brush Techniques in General Techniques, Chapter 2) along drapery lines. Decorate ends of drape with a Gold Light, Vermilion and a Midnight Blue line, and a row of Gold Light dots along the edge.

5 Paint the rest, that sits under the book, in Vermilion with a Midnight Blue line around the edge. The edges of the pages of the book are painted in Terracotta, with a coat of Gold Light brushed over the top. The pages are painted in Raw Sienna with a dry brushing of Antique White on top. Run a Terracotta line down through the spine of the book. The binding (cover) of the book appears as a Burgundy line round the edge. Paint a letter in the corner of the page, with a few little commas as illuminated leaves and a few squiggles across the page as lettering. The pen in the monk's hand is painted in Raw Sienna, the burnisher in the other hand is Midnight Blue and White (2:1).

6 The lining of the monk's garment is painted in Vermilion. The garment is painted in Burgundy and Naphthol Crimson (1:1). Trace on the fold of the garment and float a side load of a mixture of Terracotta and Raw Sienna and Copper (1:1:1) along each fold. Outline the edge of the sleeves, neck and hemline in Midnight Blue.

7 Paint the hair and beard in Black, and then add little Black and White (2:1) lines on top.

8 The archway columns and letters are painted in Raw Sienna, Terracotta and White (2:2:1). Float a side load of Burnt Sienna on the

top and bottom edge of the archways and around the horizontal shapes at the top of the capitals, and then float a side load of Spruce just inside the lower edge of the archway. Float a Gold Light side load down the column on the right and the column that forms the letter 'L' on the left. Paint the textured commas on the capitals in Copper. The letters 'IBER' have a thickish Gold line down the left side and thinnish elsewhere. Paint a row of Gold Light dots down the centre of each letter. The floral decoration near the letters is painted with textured Vermilion commas. The archways, columns, letters are outlined in Midnight Blue.

9 Paint the area above the buildings in Raw Sienna and White (3:1)

10 The buildings are painted as follows:

Domed Building
Dome: Phthalo Green
Outline: Spruce
Walls: Phthalo Green
Windows: Phthalo Green and White (2:1)

Tall Buildings
Walls: Midnight Blue and White (1:1)
Windows: Midnight Blue and White (2:1)
Outline: Midnight Blue

Smaller Buildings
Walls: Midnight Blue and White (2:1)
Windows and Outline: Midnight Blue

11 Two versions of the quotation from the The Prologue to *The Canterbury Tales* are given; one is suitable for the inside of a box, the other for around the side. Paint whichever is appropriate for your project and pattern.

12 Antique, varnish and wax. Rub gold wax around all edges.

ILLUMINATED FLOWERS

Lenten is come with love to towne,
With blosmen and with briddes roune,
That al this blisse bringeth.

SPRING SONG.
anon. 14th Century

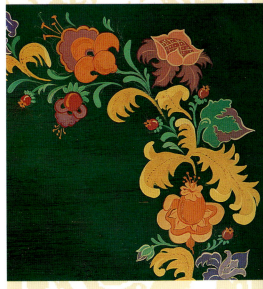

MANUSCRIPTS FROM OTHER ages have a multiple appeal. For the scholar, there is the text, written in Latin or old French, English or German. The artist takes delight in the colours, the miniatures of people, places and events. And the highly decorative documents are often further embellished with a wide variety of stylised floral and decorative motifs. The floral designs I have created and worked into this project have their origin in the rich ornamental illumination of Italian manuscripts, notably some detail from the early fifteenth century *Visconti Hours*.

Degree of Difficulty - 2

MATERIALS

Tray 550 mm x 400 mm (22" x 16")
Background colours: Midnight Blue and Spruce
Decorative colours: Dioxazine Purple, Titanium White Terracotta, Raw Sienna, Burgundy, Copper, Spruce, Vermilion,.
Brushes: Nos 1 & 3 round, liner
Miscellaneous: crackle medium, patina, Burnt Umber oil paint, varnish and wax

PREPARATION

Paint the top of the tray (other than the curved edges) with Midnight Blue Background Paint. Paint the edges of the tray, and underneath, in a mixture of Spruce and Midnight Blue Background Paint (3:1). You may now choose to add a little crackle medium. When dry, paint the top of the tray in a Spruce/Midnight Blue mixture and the edges and underneath in Midnight Blue. Sand when dry, then lightly distress so some of the underneath colour peeps through.

Trace the pattern and follow the directions below to apply to the surface. The pattern should be repeated four times, interlocking to form a ring around the tray.

Divide the tray into quarters by drawing a line from centre end to end and centre side to side. Place the centre of the design onto the

centre point at the end of the tray (approximately 3 cm [1¼"] in from the end of the tray base). Make a mark where the ends of the design finish. Repeat at the other end.

Place the centre of the pattern on the centre mark at the side and make a mark at the ends of the design.

Check now and see if the design interlocks. Adjust accordingly if needed — you can always add a comma or two so that the design flows. When satisfied that the design creates a lovely ring of flowers round your tray, repeat the above and trace the pattern onto the surface.

PAINTING THE IMAGE

The flower can be painted by following the colour scheme provided with the pattern — or you can create your own. Here are a few additional instructions:

1 Block in all base colours first, most colours will need two coats.

2 Use the appropriate-sized bush so that you can more meticulously paint the shape. A range from numbers 1 to 3 will give you a good result.

3 Add the detail to each flower and leaf.

4 Outline, where necessary, with a fine liner brush.

5 Antique, varnish and wax.

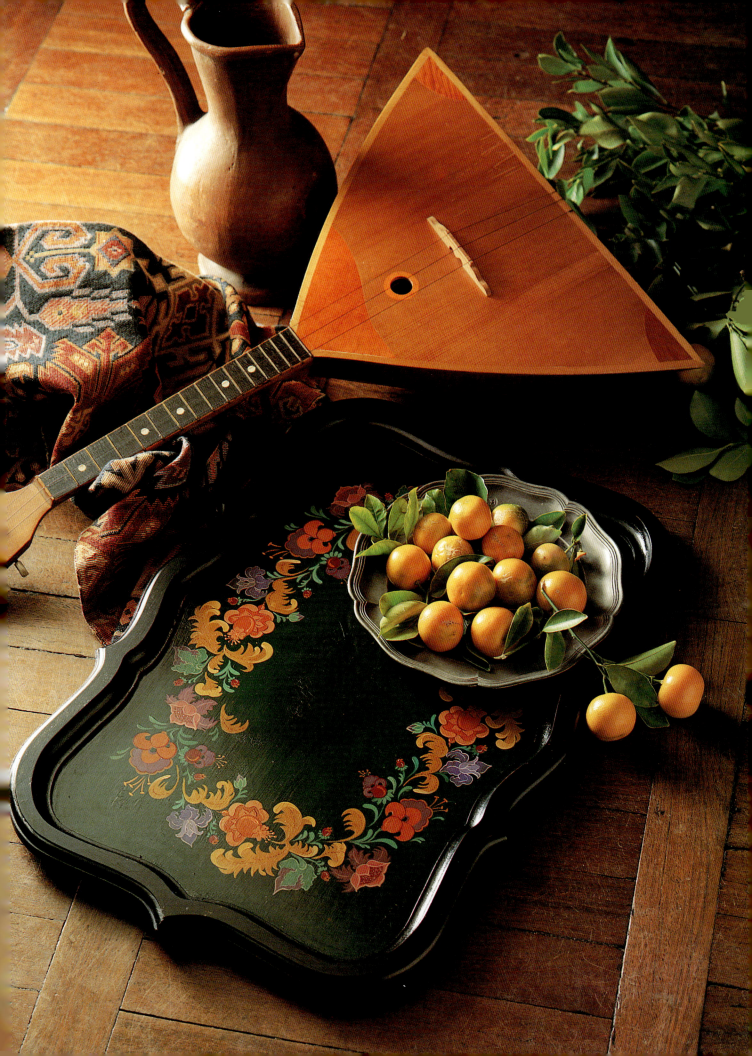

ILLUMINATED LETTER

~

A peccatis nostris libera nos Domine.

From our sins, set us free O Lord.

FROM LITANY OF SAINTS,
Roman Easter Liturgy

MANUSCRIPTS WERE OFTEN highly decorated, with illuminated borders and inset miniatures. A feature of many of these documents was the enlarged capital letter that indicated the beginning of a chapter or subdivision in the text. Capitals were painted with strong, deep and striking colours and the use of gold paint or gold leaf was common.

There are many attractive alphabets available that can be adapted for this design. Choose a simple letter and connect the leaf patterns provided in the design.

Degree of Difficulty - 2

MATERIALS

A flat board with a cut-out for the letter slightly offset in the top left corner, 280 mm x 240 mm (11" x 9") and an insert on which to paint the design
Background colours: Pimento
Decorative colours: Gold Light, Spruce, Burgundy, White Pearl, Antique White, Black, Copper, Naphthol Crimson, Raw Sienna, Terracotta, Burnt Umber
Brushes: Nos 00, 1, 2 round, a liner, background brush
Miscellaneous: patina, Burnt Umber oil paint, varnish, wax.

PREPARATION

Base coat the whole surface in Pimento base paint and sand when dry. Paint two good even coats of Gold Light and sand well when dry.
Trace the initial and apply to surface. Trace the leaves and music from the design supplied. Apply the music design to the surface. Adjust the leaf pattern so that it relates to the initial, and then apply to surface.

PAINTING THE IMAGE

1 Paint the initial in a mixture of Burgundy and Naphthol Crimson (1:1) and outline it with a thickish Copper line. Paint a Spruce line along the left side of the letter.

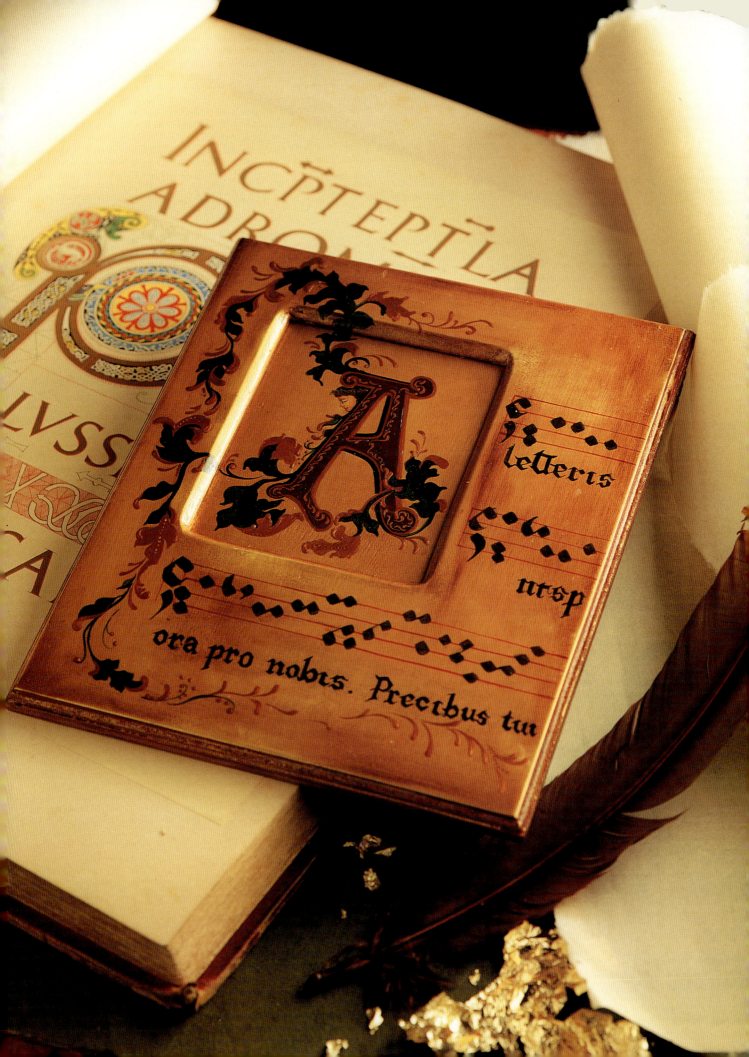

2 The decoration on the initial is a series of tiny Copper textured commas; (use a No 00 or liner brush).

3 Where the leaves appear green, paint in a mixture of Spruce and White Pearl (3:1). When dry, add more White Pearl to the original mixture (1:1) and paint half of each leaf. Paint the veins in straight Spruce. Paint the 'turnbacks' of the leaves in Copper.

4 Add textured commas on some of the Copper turnbacks and then run a series of Copper dots down the centre of some of the leaves, as shown on pattern.

5 Paint the textured commas at the lower edge of the design in Copper.

6 Paint the face (top left side of initial) in a flesh-colour mixture of White, with a tiny touch of Raw Sienna and Terracotta. Paint the hair, features and outline the face in Burnt Umber. The wreath in the hair is painted in Spruce and White (2:1) with Naphthol Crimson dots for the berries.

7 Paint the music lines in Naphthol Crimson and the music notes in a mixture of Black and White Pearl. The lettering is painted in Black.

8 Antique quite heavily, leaving a little extra in some spots, particularly around the edges.

9 Varnish and wax.

5

SAINTS,
SCHOLARS,
&
SYMBOLS

Religion in the

Middle Ages

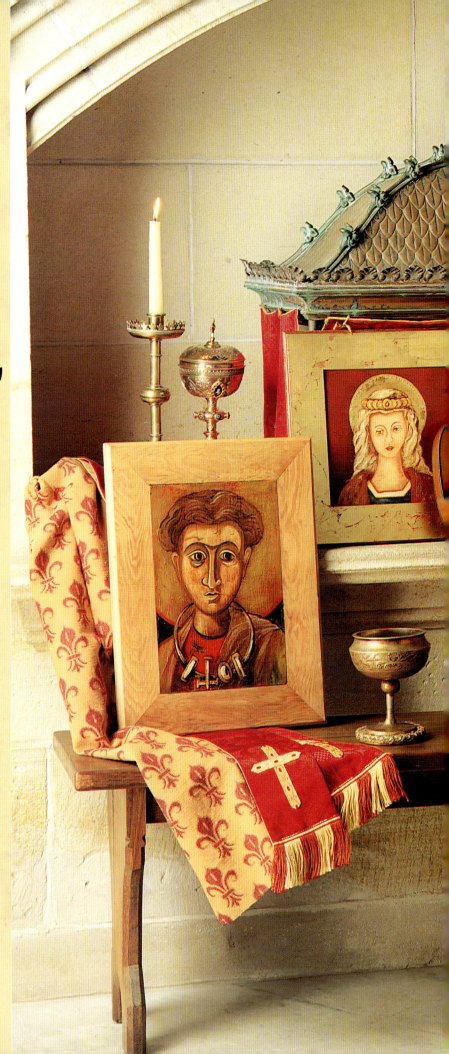

3 There are a few little Copper dots applied with a stylus down through the centre, and a Copper line around the lower edge of the lid of the box.

4 Varnish and wax.

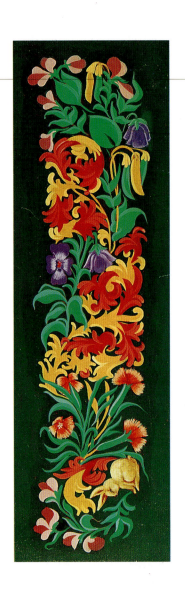

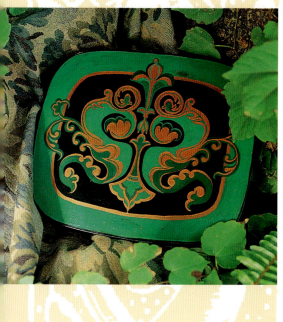

MEDIAEVAL DESIGN

~

All things began in order,
so shall they end,
and so shall they begin again.

SIR THOMAS BROWNE
The Garden of Cyrus, 17th century

AS WELL AS DECORATIVE flowers and animals, elaborate patterning and design was a feature of mediaeval ornamentation. Architecture, tapestry, mosaics and tiles, stained glass windows, sculpture, as well as handwritten documents, are full of complex, symmetrical and free-flowing designs.

The symmetrical design I have adapted to create this project for you is taken from a thirteenth century stone border carving from the cathedral in Laon in France.

Degree of Difficulty - 1

MATERIALS

Flat plywood box, 210 mm x 250 mm (8½" x 10")
Background colours: Midnight Blue
Decorative colours: Spruce, White Pearl, Copper
Brushes: No 3 and 1 round
Miscellaneous: varnish and wax, sandpaper 220.

PREPARATION

Paint all surfaces of the box with two coats of Midnight Blue and sand when dry.

PAINTING THE IMAGE

1 Trace the design and apply the image to the box.

2 This design is painted in a very limited colour scheme and can be completed simply by following the picture. It is painted by applying 1–2 coats of the following colours in the appropriate places:

Light Green: Spruce and White Pearl (1:2)
Dark Green: Spruce and White Pearl (1:1)
Copper.

It is almost impossible to exaggerate the importance of the links between religion and social life during the Middle Ages, both in the eastern and the western world. With the birth of Mohammed, late in the sixth century, the significant development of the Islamic faith and culture began and this has remained to the present day. Now, Islam is coming into ever-increasing interaction with western society because of modern communications and travel.

The influence of Christianity and the Christian Church on the development of Europe in the same period has been profound. The expansion of Christianity through the missionary work of saints, such as Patrick among the Celts, Augustine in England, Boniface, the Apostle of Germany and, in a more general way, with the flourishing of the monasteries from Benedict to Bernard of Clairvaux, and later Francis of Assisi, is central to an understanding of mediaeval life in Europe. That influence had its very noticeable disadvantages but, on the whole, the Church was seen by the people of the time as a positive and valued element of their lives.

The Church was the provider and guardian of most of the art, music, manuscripts and historical records of the time. It provided most of the formal education available, as well as many of the scholars and scientists. The life of Jesus, the heroes and heroines of the Church, the great symbols of good and evil, all provided the subjects for much Church art, which was used for both decoration and educating the faithful.

The projects provided in this chapter are:

✠ DECORATIVE DRAGON

✠ ICON OF SAINT PHILLIP

✠ NATIVITY

✠ SANTA LUCIA

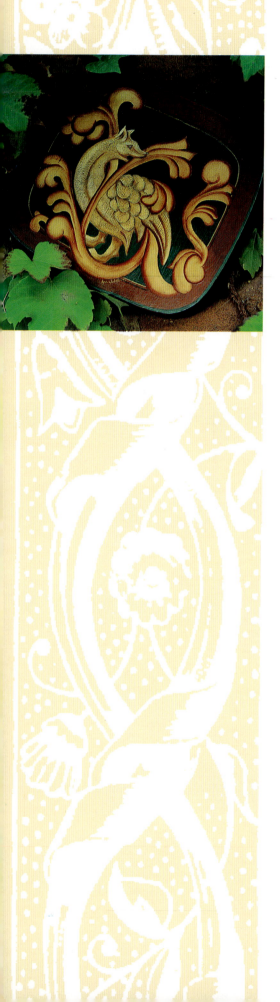

DECORATIVE DRAGON
~

Done is the battel on the dragon blak
Our campioun Christ confountet has his forces.

ON THE RESURRECTION OF CHRIST
Dunbar, 14th Century

MEDIAEVAL ARTISTS DRAW constantly on nature for images and imagery. It is the inspiration for so much of the artistic expression — decorative designs for murals, manuscripts, architecture, tapestries, paintings.

The artist's innate inventiveness often departed from reality to create wonderfully fanciful and imaginary creatures, like the dragon in the project. This delightful creature, Dragon Biting Leaf Tail, is adapted from a sculpture in the portico of the Abbey Church at Maria Laech in Germany, and is twelfth century.

Degree of Difficulty - 2

MATERIALS

Plywood Box, 250 mm x 210 mm (8½" x 10")
Background colours: Turquoise and Terracotta
Decorative colours: Spruce, White Pearl, Raw Sienna, Gold Oxide, Red Oxide and Titanium White
Brushes: round No 3, a liner, background brush, varnish brush
Miscellaneous: crackle medium, sandpaper, carbon paper, tracing paper, patina, Burnt Umber oil paint, varnish and wax.

PREPARATION

Using a 25 mm (1") background brush, paint the outside lid and base of the box with a good coat of Turquoise background paint, and allow paint to dry. Paint the inside of the box with Terracotta paint and when dry, add a thinnish coat of crackle medium to most of the surface, inside and out. When dry, paint the outside of the box Terracotta and the inside Turquoise. Sand well.

Trace a line that is approximately 25 mm (1") in from the edge on the lid of the box. Mix Spruce with White Pearl (3:1) and paint the inside shape (the area that the image will be painted on). With your liner brush, also paint a fine Spruce line 4 mm (⅛") outside this shape.

Paint a 4 mm (⅛") line around the outer edge of the top of the box, and around the top and bottom edge of the sides of the box, in the Spruce/Pearl mixture. Mix Raw Sienna and White and, with your liner brush, paint a fine line around the edge of the large Spruce shape.

Trace pattern and apply it to the box.

PAINTING THE IMAGE

1 Using a No 3 round brush, paint the Dragon with two good coats of Raw Sienna.

2 Load your brush with Raw Sienna and then take a side load. Run the side load around the edge of all the small curved feathers on the back of the Dragon.

3 Mix Raw Sienna and White (3:1) and, using a flat 7 mm (¼") brush, dry brush all over the Dragon, making sure you move in the direction that the bird takes, e.g. make a lovely curved swoop down the neck and breast, around the shape of the jaw etc.

4 Add a little more White and dry brush on a few lighter highlights.

5 Float straight Raw Sienna around all edges of the Dragon, in and around ears and jaw, the two lines down the tail and the lines that follow the line of the neck and breast.

6 Paint in the lines for the eye in Raw Sienna and add a flash of Raw Sienna and White mixture for the pupil.

7 Mix Raw Sienna and Gold Oxide (2:1) and paint all the leaves with a good coverage.

8 Load your No 3 round brush as for a float with Red Oxide, and float colour all around the edges of the leaves.

9 Write the verse inside if desired.

10 Antique, varnish and wax.

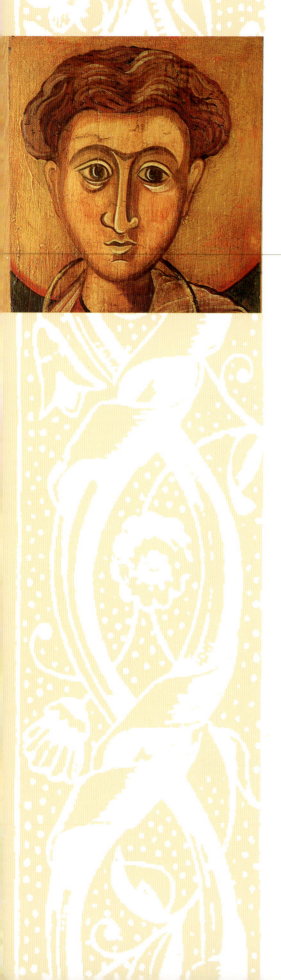

ICON OF
SAINT PHILLIP

~

Lord, show us the father and that is enough for us.

GOSPEL OF JOHN.
Ch. 14

ICONS, REPRESENTATIONS OF SAINTS or religious themes, usually on wooden panels, remind us of the powerful influence of Orthodox Christian Churches on the religious traditions of Europe after the time of the Emperor Constantine.

This is a late eleventh century detail of an icon that presents the Apostle Phillip, with two warrior saints, Theodore and Demetrius. His face, full of exalted spirituality, neverthless preserves faint traces of the portraiture of the late Hellenistic period.

Degree of Difficulty - 4

MATERIALS

Rectangular frame, 450 mm x 350 mm (18" x 14") with inserted board measuring 220 mm x 300 mm (9" x 12")
Background colours: Pimento
Decorative colours: Vermilion, Titanium White, Black, Raw Sienna, Burnt Umber, White Pearl, Spruce, Phthalo Green, Gold Light, Metallic Gold, Burnt Sienna, Terracotta, Red Oxide
Brushes: Nos 0, 1, 3 round, old 25 mm (1") flat bristle, 7 mm (¼") flat
Miscellaneous: gesso, patina, Burnt Umber oil paint, varnish, crackle medium.

PREPARATION

This project is very much an exercise in building up a textured surface. You may firstly like to seal the surface you are painting on with a coat of any colour background paint. Do not bother sanding when dry.

Using an old roughish 25 mm (1") brush, apply a good thick coat of gesso in a vertical direction across the board. Allow to dry and add more gesso to any areas you feel you would like more textured. Allow drying time.

Apply a thick coat of crackle medium and, when dry, paint on a coat of Pimento background paint. Aim at having a few quite deep cracks along with a variety of other-sized ones. When the Pimento is dry, check the cracks and add more crackle medium, followed by Pimento base

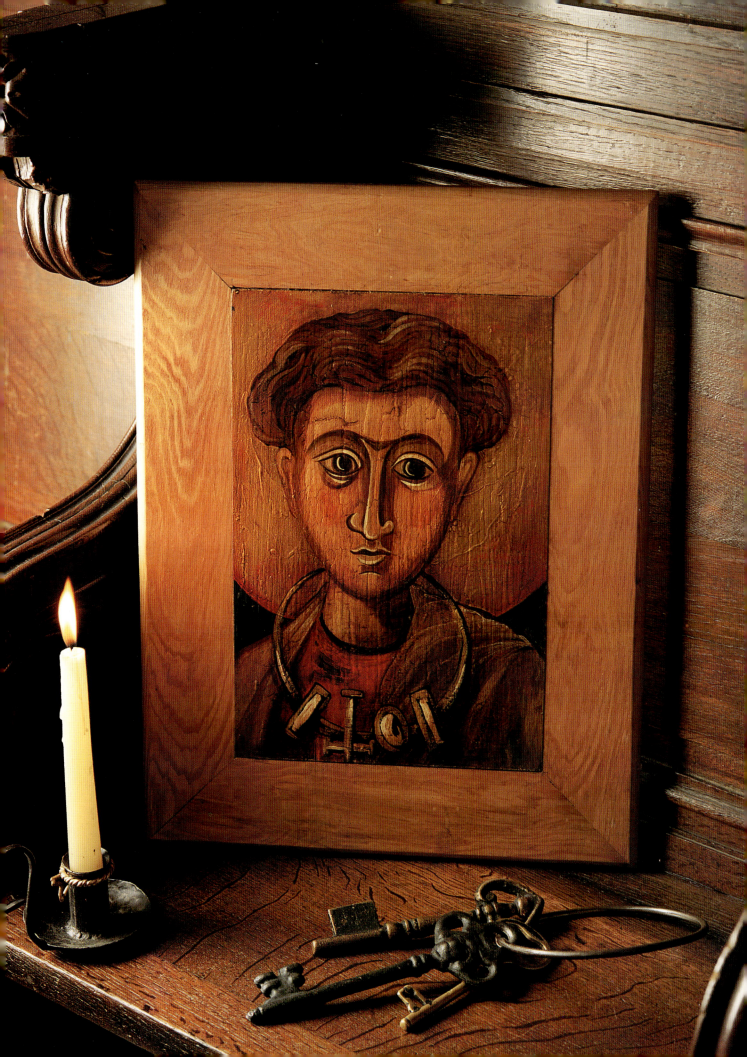

paint, when dry, to any areas you feel you would like more textured. Do not sand.

Trace on the pattern, except for features and neck piece.

PAINTING THE IMAGE

1 Block in the following shapes in the colours indicated:

Face: White with touch of Raw Sienna and Terracotta (2-3 coats)
Hair: Burnt Umber
Undergarment: Vermilion
Cloak: Burnt Sienna
Halo: Vermilion

2 When the halo is dry, apply a good thick coat of Metallic Gold. Lay your brush down almost horizontally when brushing over some of the deeply crackled areas so that some of the Vermilion underneath will show through. Float a Vermilion thick line on the bottom edge when dry.

3 Trace off the facial features and paint as follows:
- outline the eyes in a thickish Burnt Umber line, including the lower line under the left eye
- paint the iris in Burnt Umber
- add a large Black flash to the centre for the pupil
- add an Antique White curved stroke on the left side of each iris
- paint the 'whites' of the eyes in Antique White
- paint two Antique White lines under the eye (as on pattern)
- fill across the eyelid in Antique White
- paint a thick Burnt Umber line down the right side of the nose and around each nostril
- mix Burnt Umber and Metallic Gold (1:2) and paint the line across the eyebrows and down the left side of the nose, across the top lip and a fine line under the bottom lip
- add water to this mixture and paint a wash across the area between the eyebrow and the eyelid, and down either side of the nose. Extend it also down under the nose and mouth on the right side
- mix Burnt Umber, Metallic Gold and White (1:2:1) and paint a thick line down the left side of the nose, the left nostril and bottom lip.
- paint an Antique White line down the left side of the nose and each nostril (this is painted between the two lines already there)
- paint a fine Burnt Umber line on the chin, followed by an Antique White one underneath
- mix Burnt Umber and Gold (1:2) with water and float a thick

line around the entire face (shape it in a little by the temples, as in the picture)

- paint a Burnt Umber and Gold (1:1) shadow on the right side of the neck
- outline the neck and ears in Burnt Umber
- allow drying time
- make a wash of Gold Light and float it over the entire face.

4 Mix Raw Sienna and White (4:1) and brush a little halfway down the cloak on both sides from the shoulder.

5 Mix Phthalo Green and White and brush a little in each bottom corner of the cloak. Follow this with a few splashes of Gold Light.

6 Mix White Pearl and Gold Light and side load and float 'pleats' down the right-hand side, as shown on the pattern. Also, brush a little of the same mixture on the left side of the cloak.

7 Brush a little Burgundy onto the lower section of the Vermilion undergarment so as to create a shadow under the neck piece. Add a few strokes of Phthalo Green on the garment above the neck piece and a thick Black line around the neck.

8 Trace on the neck piece and paint it all in Black.

9 Add a Metallic Gold outline to each of the decorations and a few flashes of Gold to the ring. Leave a little of the Black showing around the edges.

10 Paint a good thick stroke of Antique White on the centre of each decoration.

11 Pencil on directional lines across the hair, as shown on the pattern. Build up curved lines, layer on layer in the following colours: Red Oxide and Raw Sienna (1:1) Red Oxide/Raw Sienna/White Pearl (1:1:1)

12 Apply patina and Burnt Umber oil paint quite heavily, rubbing it well into all the cracks. Allow it to sit for about half an hour before wiping off the excess.

13 Varnish and wax when ready.

14 Frame. If your frame is pine, antique it very lightly and varnish and wax. If it is made of craftwood, you might consider applying a coat of Pimento base paint and sponging on, or painting on, Metallic Gold paint.

15 Antique, varnish and wax.

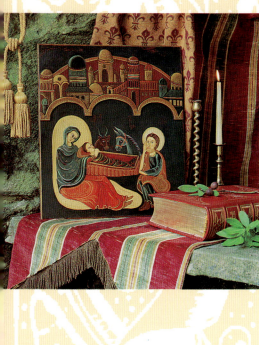

NATIVITY

Was nevere left upon linde lighter therafter
As whanne hit hadde of the folde flesch and blode ytake.
Leaf was never lighter upon the tree
Than when he had taken flesh and blood from the earth.

LANGLAND,
Piers Plowman

MARY, JOSEPH AND the Child Jesus are the most frequently portrayed subjects in religious art. In Spain and Italy, in particular, where the tradition of the Christmas crib has been a powerful educational, as well as liturgical theme, the whole scene of the nativity takes on local character and appearance. So the geography, the animals, the clothing and the buildings are much more Naples or Barcelona than Bethlehem.

The painting in this project has been adapted from a twelfth century nativity scene from the Paliotto di Avia, in the Museum of Catalonian Art, Barcelona.

Degree of Difficulty - 4

MATERIALS

Screen on legs, measuring 550 mm x 550 mm (22" x 22"). The area where the buildings are painted can be cut out of a separate piece of custom wood and glued on the image after painting, or be painted directly onto the screen.
Background colours: Midnight Blue, Pimento, Spruce Green
Decorative colours: Raw Sienna, Burnt Umber, Warm White, Terracotta, Burnt Sienna, Spruce, Metallic Gold, Light Gold, Naphthol Crimson, Cadmium Red, White Pearl, Vermilion, Hookers Green, Cadmium Yellow, Red Oxide
Brushes: liner, 00,1 & 3 round brushes, 7 mm (¼") flat brush
Miscellaneous: stylus, patina, Burnt Umber oil paint, varnish, wax.

PREPARATION

Prepare the nativity scene section of the board first. Paint the screen in Pimento, using a rough, oldish brush and giving quite a textured coat. Paint on some crackle medium and, when dry, give a coat of Midnight Blue and Spruce (1:3). Distress when dry. If you are gluing a separate piece of wood on for the buildings, do not paint the back of it, nor the area where it will be glued on the screen. Paint the area where the buildings

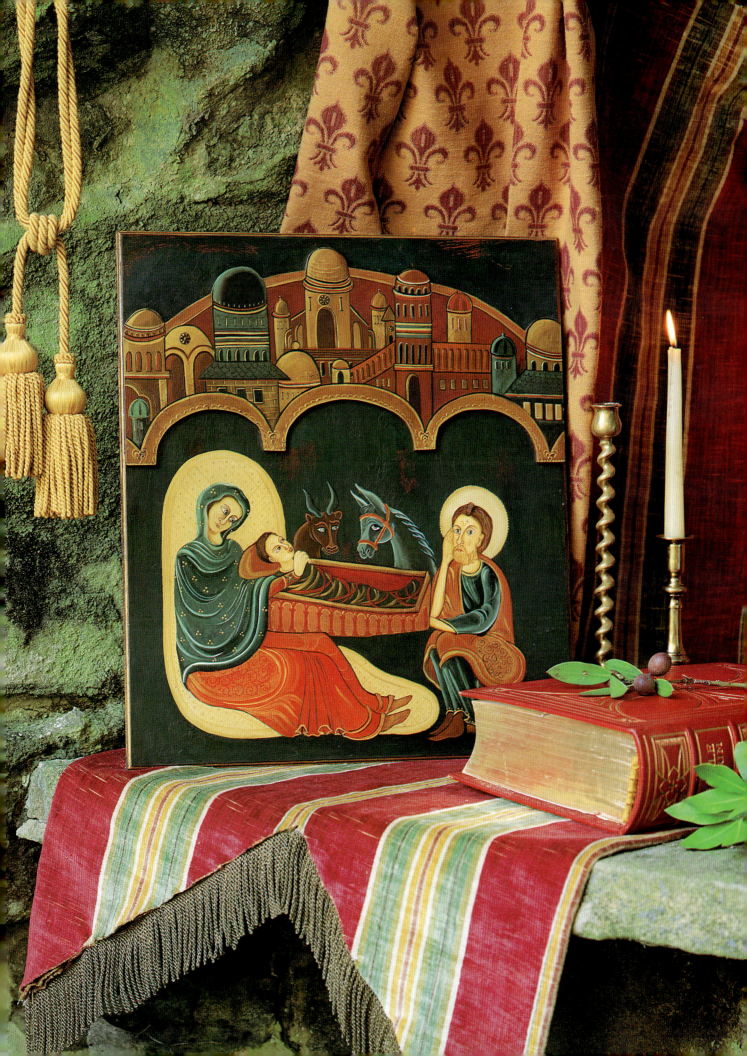

will be painted in the Midnight Blue and Spruce mixture, and then add some crackle medium before a coat of Pimento. Sand when dry.

PAINTING THE IMAGE

1 Paint in the flesh colour on faces and hands (refer to Painting Faces and Hands in General Techniques, Chapter 2).

2 Paint each of the features of the face as indicated below:
- trace on all the features and float Raw Sienna around the hairline and under the chin and the neckline, and down either side of Joseph's arms
- with a very fine brush, e.g. 00, outline all the features in Burnt Umber
- mix a Raw Sienna wash and paint it down the side of the nose
- shade from the corner of the eye, near the nose, out halfway along the eyelid and the area between the eyelid and the eyebrow, with a wash of Raw Sienna, Terracotta and White (1:1:1)
- highlight the rest of the area above the eye with a White Pearl wash
- paint the eye in Warm White
- paint the iris in a mixture of Phthalo Blue, with a touch of White Pearl
- add a Black pupil to the iris and, in a mixture of White Pearl with a tiny touch of Phthalo Blue, paint a highlight around the left side of the pupil
- 'tidy up' by repainting the lines around the eye, the eyelid and eyebrow in Burnt Umber
- paint mouth in Terracotta
- make a wash of Terracotta and let a droplet fall from a No 3 round brush onto the area of the cheek. Soak up the excess with a damp cotton bud
- paint Joseph's beard and moustache by floating a wash over the area and, when dry, paint wavy Burnt Umber lines
- the inside of the ear is painted with a little Burnt Umber
- the line on Joseph's forehead is in Raw Sienna.

3 Block in all the following shapes with the colours indicated:

Hair on Jesus and Joseph: Burnt Umber and Burnt Sienna (1:1)
Cow: Red Oxide
Horns of Cow: Black and White Pearl (1:1)
Donkey: Black, Spruce, White (1:1:1)
Aura Shape behind Mary: Pale Gold and White (2:1)
Halo behind Joseph: Pale Gold and White (2:1)

Crib, inside and out: Naphthol Crimson
Pillow behind Jesus: Terracotta
Garment on Jesus: Hooker Green and Cadmium Yellow (3:1)
Mary's Dress: Cadmium Red and Naphthol Crimson (1:1)
Mary's Cape: Spruce and White Pearl (3:1)
Joseph's Cape: Terracotta and Pale Gold (3:1)
Mary's Feet: Terracotta and Pale Gold (3:1)
Joseph's Feet: Burnt Sienna and Burnt Umber (1:1)
Seat: Burnt Sienna and Burnt Umber (1:1)

4 Float Pale Gold around the edge of Joseph's halo and add little Pale Gold dots with a stylus, around the edge.

5 With a side load of Metallic Gold on a wet brush, place the brush down with the side load on the edge of the aura around Mary and, starting near the head of Jesus and moving anticlockwise, paint around the edge. Reload the brush and turn the side load towards the centre and float a line approximately 100 mm ($\frac{3}{8}$") in from the edge. Using a liner brush and Metallic Gold paint, apply the lines behind Mary. Using a stylus, add a Metallic Gold dot to each square that has been created.

6 Retrace any lines on the design that have been painted over.

7 Mix a wash of Spruce, load the brush and side load with White Pearl. Apply the paint along the pattern lines on Joseph's undergarment.

8 Loading as above (No. 7), float the paint around the back and top of the cloak on Mary's head, and then on the edge of the cloak around Mary's face. Reload and, placing the side load on the edge of the fold line, proceed to float paint along each load.

9 Float two Metallic Gold lines, as painted around aura, around the shape on Mary's hip. Fill the curved shape created on the hip with a Metallic Gold wash. Paint on the highlight lines on Mary's dress in Metallic Gold wash.

10 Paint the curved shape on Joseph's hip in Metallic Gold wash. Float Metallic Gold around the edges of Joseph's cloak and add a few extra highlight lines. Paint a Gold line around the neck, end of sleeve, and hemline of Joseph's undergarment, as well as a row of Gold dots to the hemline. Brush a little Gold across Joseph's seat.

11 Paint the following in Burnt Umber:
 • the swirls on Joseph's cloak
 • a few lines along some of the Gold highlight on the cloak

- an outline around Joseph's arm and hands
- around Joseph's feet.

12 The swirls on Mary's hip are in Naphthol Crimson. Outline Mary's skirt, paint the folds on the skirt and Mary's feet in Spruce.

13 Using a stylus, apply the Metallic Gold dots to Mary's cape.

14 The flower on the end of Mary's sleeve is in Spruce with White Pearl (1:1) with Gold bands.

15 Paint Metallic Gold wash line and Naphthol Crimson lines across the garment of Jesus, and outline in Burnt Umber.

16 Paint a Burnt Umber edge around the crib and then paint on a Metallic Gold wash.

The area between the columns on the side of the crib and the outside end of the crib is in Terracotta and Pale Gold (2:1). Outline the left side of the column in Naphthol Crimson and the archway and right side of the column in Metallic Gold. Put a Vermilion dot, outlined in Gold, above each column.

17 Wash Metallic Gold over the pillow.

18 Paint fine Gold and Burnt Umber lines through the hair of Jesus and Joseph.

19 Paint a Red Oxide and White (1:1) line around the areas on the cow, as shown in the picture, i.e. the back of the neck, top of the head, ears, eyebrows, down and around nose, mouth and jaw. Paint a Black line inside ears, under eyebrow, down both sides of nose, around jaw through mouth, and fill the end of nose. Outline the eyes in Black, painting the eyeball in Antique White and the iris in Black. Paint a Gold circle in the iris, leaving a Black pupil in the centre. Paint a Black and White Pearl (1:2) highlight down the left side of the cow's horns.

20 Mix Spruce, Black and White (1:1:3) and paint highlights on the donkey, i.e. outline the head, highlight the ears, and paint lines across the forehead and the mane. Paint the eyeball in Antique White. Paint the iris in Black and add a Gold curved flash as a highlight on the iris. The strapping is painted in Naphthol Crimson outlined in Metallic Gold.

THE BUILDINGS

You can be as creative as you like with the buildings — the lovely warm colours will give the same effect no matter where you use them. You do not need to follow my painting exactly.

The buildings are basically Raw Sienna and White (3:1), Terracotta,

Red Oxide, Burnt Sienna and Burnt Umber (1:1) and Spruce and White Pearl (2:1).

Follow the picture as a guide and begin by blocking in all the basic colours. Highlight a couple of the domes with a lighter shade of the base colour. Now add the decoration. Most of the windows are Spruce outlined in Metallic Gold. The stripes are a combination of the basic building colours. The brickwork is in Raw Sienna outlined with Metallic Gold. Outline all buildings in Spruce.

Paint the archway on top and the three below in Burnt Sienna and Burnt Umber (1:1) and, when dry, paint over a Gold wash. Outline with Metallic Gold. Add a Spruce line to the inside edges. Add the textured Metallic Gold commas around the edge of the lower arches.

I would suggest antiquing all areas, other than the figures, quite heavily. The figures need only a 'wipe' of antiquing medium to mellow them. This will make the figures appear quite luminous against the dark background. Varnish and wax.

SANTA LUCIA

~

*For Saints may do the same things by
the Spirit, in sincerity,
Which other men are tempted to.*

BUTLER, HUDIBRAS.
17th Century

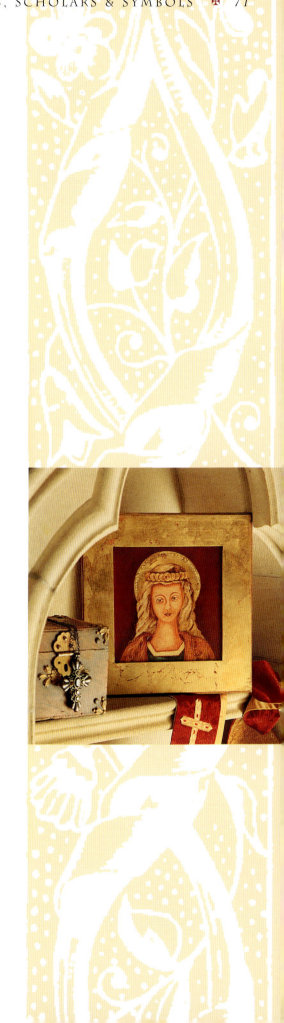

This painting was inspired by the charming twelfth century Italian fresco painting of Santa Lucia.

The frame and halo can be guilded in Dutch Gold Metal or simply painted in Metallic Gold paint.

Degree of Difficulty - 3

MATERIALS

A frame, 350 mm x 350 mm (14" x 14") with board insert, preferably square, 220 mm x 220 mm (9" x 9")

Background colours: Pimento

Decorative colours: Raw Sienna, Titanium White, Terracotta, Metallic Copper, Gold Light, Spruce, White Pearl, Burnt Umber, Red Oxide, Antique White

Brushes: Nos 00, 2, 3, 7 mm (¼") flat
Miscellaneous: gesso, patina, Burnt Umber oil paint, varnish, wax, stylus, grade 180 and 600 wet and dry sandpaper.

If you wish to gold leaf the frame and halo, you will need the following materials:
- schlagmetal or Dutch Gold
- size
- grade 220, grade 600 wet and dry sandpaper
- old piece of non-textured silk or soft cotton
- cotton wool balls
- thick thread
- lid of a bottle
- cotton gloves
- soft brush
- sponge brush

PREPARATION

Paint the insert board with a good coat of Pimento background paint. When dry, apply a coat of crackle medium across the surface, enough to produce fine crackles. When dry, apply one more coat of Pimento.

Painting Frame

Give one coat of Pimento and sand with 180 grade sandpaper when dry. Paint on one more coat of Pimento and, when dry, sand with 600 wet and dry paper to produce a very smooth surface. Paint on two coats of Metallic Gold or Gold Light (personal preference) sanding with 600 dry paper between and after coats.

Gilding Frame

I would suggest that if you have not done gilding before, that you prepare and use a practice board for your first attempt. Prepare your frame or practice board as follows:

1 Three coats of Pimento. Apply very carefully and evenly with a sponge brush. Allow to dry totally between coats, before sanding well with 220 sandpaper.

2 Paint on two to three more coats of Pimento using a little water, sanding carefully with 600 wet and dry paper between the first two coats when dry, and finally with dry 600 paper. It is of absolute importance that the surface have a fine silky finish.

3 Make two to three bobs. Cut the silk or cotton fabric into 80 mm (3") squares, place two to three cotton balls in the centre, draw up and wrap thread around the ends in order to form a little bob.

4 Pour a little size into a lid. Dip the bob into the size and drag it

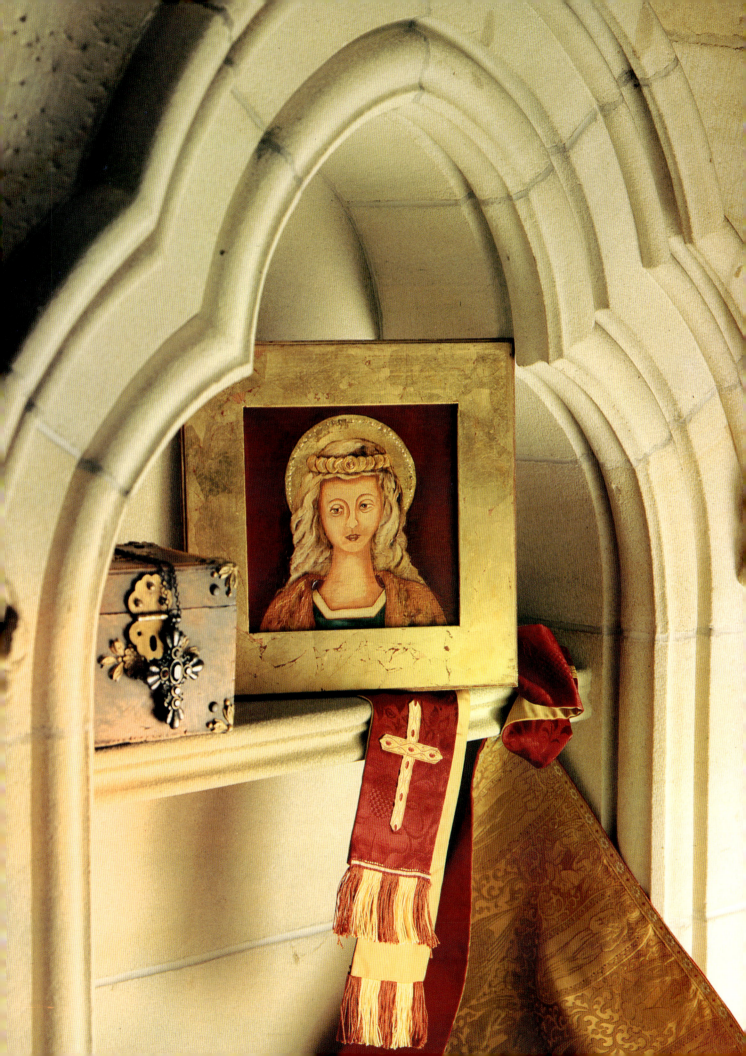

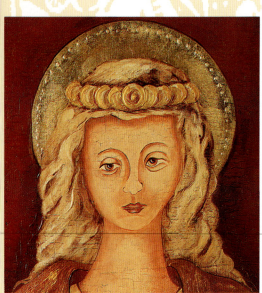

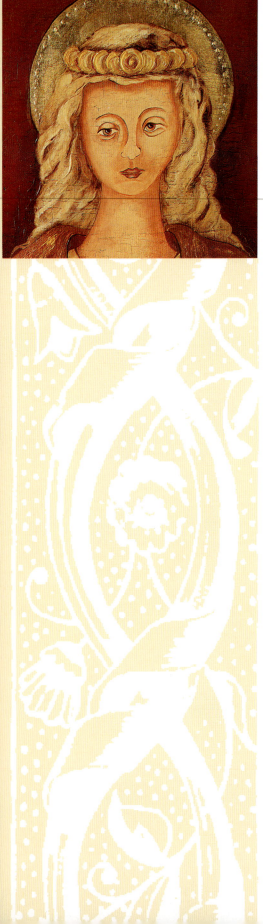

evenly down one edge of the frame. Add more size to bob as needed and lay down the size, row by row, until you have covered one side of the frame. Without adding more size, go back over the area in the opposite direction making sure the size appears even and very thin — very little size is needed. Cover the entire frame in this manner.

5 The size will take 20-30 minutes before it is ready for the Dutch Metal to be applied. Test with your knuckle. If the size is too tacky it will 'grab' at the knuckle. If there is no grabbing feeling, it is ready.

6 Wear cotton gloves so as not to oxidise the metal. Cut the metal into pieces approximately 5 cm (2″) square.

I have applied the metal so that small crazing or veins appear, rather than producing a flat unbroken surface. I like the textured look that this space creates. This can be produced by simply dropping the metal onto the surface so that a number of crinkles appear. Pat the metal down lightly with a soft brush. Continue around the frame, butting one piece up against another, overlapping slightly. When you have covered the frame, rub over the entire surface with a gloved finger, flattening out each piece of metal and giving special attention to where creases appear. Any gaps that you feel are rather big can be filled with the little flake that will accumulate from the rubbing.

7 Apply two to three coats of satin varnish.

8 Trace the design and apply to the insert board. Using a stylus and Metallic Gold paint, apply dots around the halo. Allow to dry well. Using a brush, apply a thin coat of size to the entire halo area.

9 When ready, apply the metal over the size.

PAINTING THE IMAGE

1 Apply gesso to the following shapes:

Hair: apply long strokes following the general curves of the hair
Wreath in Hair: apply following the shapes in design
Cloak: apply in haphazard strokes to produce a little general texture across surface

When the surface is dry, repaint in Pimento.

2 Block in the face and neck in a mixture of White, with a little Raw Sienna and Terracotta added.

3 Trace on the features. Make a watery mixture of Raw Sienna and Terracotta (1:1) and float a wash over the following areas:
 • around the hairline

- under chin and down neck
- between eyebrows and eyelids
- down sides of nose
- across eyelids
- fine line under lower eyelid.

4 Make a paler mixture by adding White to the above wash and paint the following:
- the outer end of area between eyelid and eyebrow
- across the centre part of eyelid
- a little under eye, brushing across cheekbone.

5 Paint the whites of the eyes in Antique White. The iris is painted in Raw Sienna, Terracotta (1:1). Add a little White and paint a highlight on the left side of the iris. Paint the pupil in Burnt Umber and add a flash of White to the left side of it.

6 Using a liner brush, or a 00 round brush, loaded with Burnt Umber, paint back over any outlines that need freshening.

7 Paint the lips in Terracotta. Add highlights to the front of the lips in Terracotta and White (1:1). Outline with fine Burnt Umber line.

8 Basecoat the hair with one coat of Red Oxide
- dry brush a mixture of Raw Sienna and Terracotta and White (2:2:1) over the surface of hair (refer to Dry Brushing in General Techniques, Chapter 2)
- dry brush dark tones on low surface areas in Burnt Umber
- add White to the Raw Sienna and Terracotta mixture above and dry brush on highlights, particularly on raised gesso areas
- add more White for a few extra light highlights.

9 The wreath in the hair is painted in Metallic Gold. Allow some of the Pimento to still show through.
 Add a highlight to the top of each shape by mixing White into Metallic Gold.

10 Paint the dress in Spruce and White Pearl (3:1).

11 Paint the band on the dress in Antique White and add a Gold Light with Pimento line either side.

12 Paint the cloak in Copper and add a few 'splashes' of Gold Light.

13 Antique very lightly.

14 Varnish and wax.

6

TRAVELLERS, TOWNS, & TRADERS

Life in

Mediaeval Towns

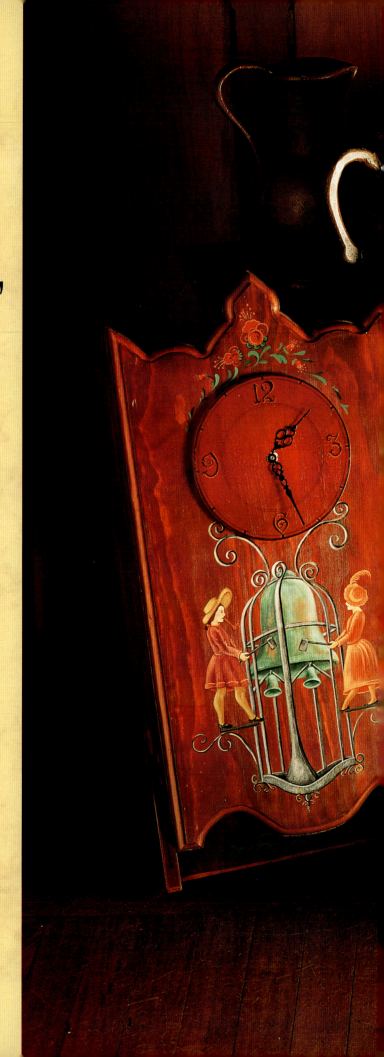

In our day, those who travel in Third World countries often remark on the number of people that they see on the road, walking from place to place. With our access to cars, trains and planes, we run the risk of taking for granted the phenomenon of long-distance travel, especially in past centuries. Chaucer's *The Canterbury Tales* is based on the travel of pilgrims. We know detail of the voyages associated with the crusades, of the pilgrimage route through southern France to the shrine of Saint James of Compostella in Spain, of the commercial voyages of Arab traders. Just how much time was spent in arriving at one's destination, or what dangers were faced on the way, are not so clearly spelled out. They must have been considerable. The nature and the slowness of travel necessitated the use of inns and accommodation available in villages and towns with their own particular character, location and fortifications. The town or monastery bell was an important feature of town life which helped to regulate the daily rhythm of the community.

The three projects chosen here hopefully capture some of the spirit of town life and some of the fascination of travel and far-off places. They are:

✠ MEDIAEVAL CLOCK

✠ ITALIAN TRAVELLERS

✠ MARCO POLO

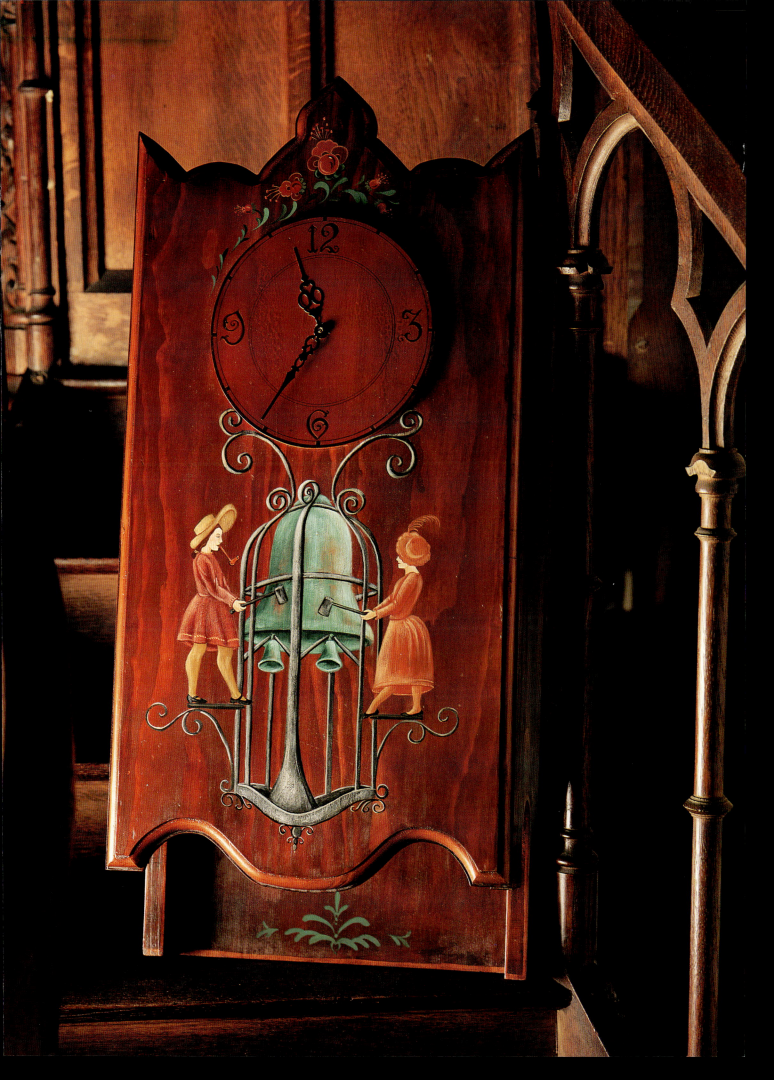

MEDIAEVAL CLOCK

~

Even such is Time, which takes in trust
Our Youth, our joys, and all we have,
And pays us but with age and dust.

SIR WALTER RALEIGH
16th Century

THE DESIGN OF this clock has been adapted from a fourteenth century original in Dijon, France, known as the Jacquemart of Notre-Dame. The clock was made in Courtray about 1360 and taken to its present setting by the son, or grandson, of its maker, from whom the name Jacquemart is derived.

Degree of Difficulty - 3

MATERIALS

Flat wall clock, approximately 400 mm x 280 mm (16" x 11½") or casement clock, approximately 600 mm x 320 mm (24" x 13")
Background colours: a wood stain of your choice or Pimento background paint
Decorative colours: Black, Spruce, Terracotta, Vermilion, Raw Sienna, Silver, Naphthol Crimson, Burnt Umber, Copper, Burgundy
Brushes: 7 mm (¼") flat, No 3 round, a liner
Miscellaneous: compass with drawing pen, eraser, sandpaper, tracing paper, carbon paper, stylus, carbothello pencil.

PREPARATION

If your piece of wood has a grain, stain it the colour of your choice. I have used a wash mixture of Pimento background paint and Burnt Umber flow paint (3:1), plus water, applied with a soft cotton cloth (refer to Staining Directions in General Painting Techniques, Chapter 2). If your piece is made of craftwood, paint it in the colour of your choice. I would suggest a 'darkish' colour. Sand when dry, and trace and apply the design.

PAINTING THE IMAGE

The Clock Face

1 Plug the hole where the hands are attached with a piece of eraser cut to the size of the hole. Mark out with a carbothello pencil where you

wish to paint the circles of the clock face. The outer line on my clock is 190 mm (7¾") in diameter.

Mix Copper paint with water to make a good flowing mixture and load the receptacle on the end of the compass that carries ink. Place the point of the compass into the centre of the rubber and draw a circle with the paint. To make a thick line, keep the compass in the hole and draw two or three more circles inside each other. I have drawn two thinner circles towards the centre of the face and a black one on the far outer edge.

Paint the numbers in Black.

Face and Hands of the Figures

2 Paint the face and hands in flesh colours and then add the features (refer to Painting Faces and Hands in General Painting Techniques, Chapter 2).

3 Block in the following shapes in the colours indicated below:

Bells: Copper
Gentleman's Hat: Raw Sienna and White (3:1)
Lady's & Gentleman's Stockings: Raw Sienna and White (3:1)
Gentleman's Costume: Burgundy and Naphthol Crimson (3:1)
Lady's Dress and Hat & Feather: Terracotta.

4 (Refer to Dry Brushing in General Techniques, Chapter 2.)
The three bells are dry brushed with several layers of tones of Spruce and White, painting from dark to light. Dry brush over the surface and inside of the bells with each tone, being sure to allow some of the Copper to still show through. Highlight down the right side of each bell in lighter tones.

5 Retrace all the iron work on the bell that has been painted over. Mix Black and Silver (4:1) and paint in all the iron work. Add White and Silver to the mixture and dry brush down the iron work, leaving the edge of each strip in the original dark colour. Refer to picture and pattern.

6 Mix Raw Sienna and White (2:1) and dry brush highlights on the man's hat, down the back of his stockings and down the front of the lady's stockings. Paint in the man's pipe in the same mixture and add in a highlight.

7 Add just a 'touch' of Burgundy to Vermilion and dry brush on the highlights on the man's garment. Paint Copper dots around lower skirt, neckline and end of sleeve.

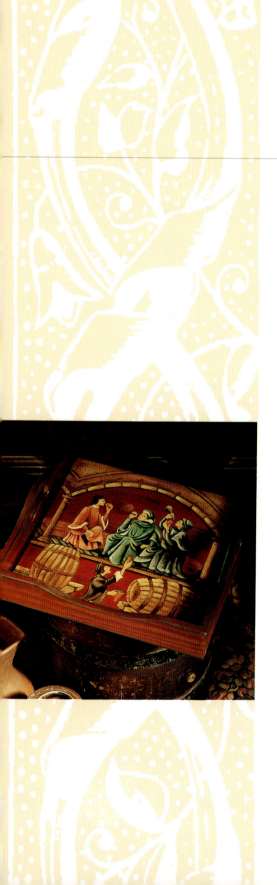

8 Mix Vermilion and White (2:1) and, following the picture, lightly dry brush highlights down the front of the lady's dress and sleeves and across the hat. Paint a fine line over the feather. Paint a Copper line around hemline, neckline, edge of sleeve and waist, edge of hat and hatband.

9 Paint the hammers in a mixture of Black and Silver (4:1) and then dry brush a little Silver as highlights.

10 Paint flowers on top and sides of clock, leaves and commas in Spruce and White (3:1). Some of the commas are Spruce and White (1:1).

The bulb and top petals of the large flowers are blocked in a mixture of Burgundy and Vermilion (1:1). Paint the stamen in the same mixture. The side petals of the large flowers are Burgundy and Vermilion (2:1). Add a light and dark comma down the side of each bulb. The little flowers are in the same Burgundy Vermilion mixture (1:1) with a lighter shade for the daisy top and the stamens, Burgundy and Vermilion 1:1 with a touch of white. Add a light and dark comma down each side of the bulbs.

11 Antique, varnish and wax.

ITALIAN TRAVELLERS

~

If all be true that I do think
There are five reasons we should drink:
Good wine - a friend - or being dry -
Or lest we should be by and by
Or any other reason why.

DEAN ALDRICH
17th century

THE PAINTING IN this project is an adaptation of one of the illustrations from a late fourteenth century treatise on the Seven Deadly Sins. The particular detail concerns a group of Italian travellers, who seem to serve in the manuscript as a warning that too much revelry can lead to drunkenness.

Degree of Difficulty - 4

Paint the strappings around the barrels in Burnt Sienna. Add White to Burnt Sienna and brush on a lighter tone towards the sides of the barrel on the left, and the centre of the strapping on the barrel on the right.

Paint the tops in Burnt Umber and add a little highlight on the top. Paint a few studs around the strapping in Burnt Umber.

Garments: Paint on the folds using the dry brush technique, remembering that it is important to retain the depth in the folds. The highlights are painted by building up levels of approximately two to three shades. Each time a lighter shade is added it is important to still allow some of the underneath deeper shade to show through. Keep in mind that the light is coming from the left.

The mixtures given below indicate the depth of colour, for the first layer of highlight:

Figure on Left: Vermilion and White (3:1)
Middle Figure: Spruce and White (2:1)
Right Figure: Midnight Blue and White (2:1)
Lower Figure: Burnt Umber and White (2:1)

- loosely outline each garment in the original colour including a line down near each hem
- the buttons on the vest of the lower figure in Burnt Umber
- dry brush all vessels and mugs in a lighter shade than the base colour by adding a little White to the original colour. Also paint a few lighter lines in the hair of each man – Raw Sienna and White (1:1)
- paint a 4 mm ($\frac{1}{8}$") line around the edge of the base of the tray, i.e. around the image, and also around all edges of the sides of the tray
- antique, varnish and wax.

MARCO POLO

~

In this city Kublai Khan built a huge palace
of marble and other ornamental stone.

ANON

A VENETIAN TRAVELLER and writer, and a member of a leading merchant family, Marco Polo (c1254-1324) joined his father Nicolo and uncle Maffeo on a trading expedition to China in 1271, reaching Peking by 1275. He became the favourite of Kublai Khan, China's Mongol

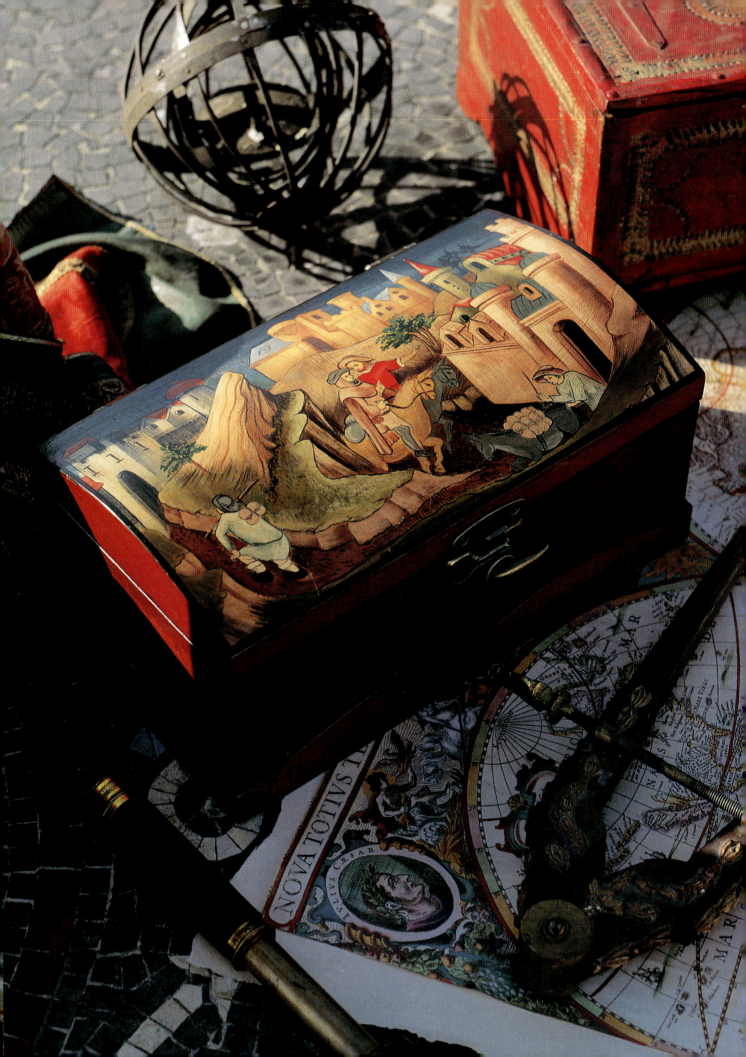

ruler, entered the Chinese civil service and later ruled the city of Yangehow for three years. Only Kublai's death in 1292 enabled the Polos to leave China; three years later they returned to Venice. Taken prisoner while fighting for Venice against the Genoans in 1296, Marco dictated his memoirs in prison. In these, he tells of places he had seen or heard of on his travels, including China, Japan, Persia, Sumatra and East Africa and describes coal, asbestos, and paper money. Marco Polo's accounts were the main source of European knowledge of China until the nineteenth century.

The source of this project is a thirteenth century painting. From this, the Peking into which Marco Polo enters, is seen very much in European perspective, with little knowledge of what the real Peking might be.

Degree of Difficulty - 4

MATERIALS

A small chest, 350 mm x 200 mm (14" x 8")
Background colours: Pale Beige, Pimento
Decorative colours: Titanium White, Black, Midnight Blue, Ultramarine Blue, Raw Sienna, Red Oxide, Pine Green, Antique Gold, Cadmium Red, Vermilion, Cadmium Yellow, Hookers Green
Brushes: 7 mm (¼") flat brush, Nos 1 & 3 round, a liner
Miscellaneous: patina, Burnt Umber oil paint, varnish and wax.

PREPARATION

Give the top of the box one coat of Pale Beige background paint. Apply a little crackle medium here and there and, when dry, give the surface one more coat of Beige paint.

Paint the sides of the lid with two coats of Pimento. If you are painting a similar box to the one in the picture, paint the lower raised edge also with two coats of Pimento. Paint the underneath of the box likewise. If the box is made of grained timber, the sides and all the insides of the box could be stained (refer to Staining Directions in General Painting Techniques, Chapter 2). If the box is made of craftwood, give the sides and insides one coat of Midnight Blue, followed by a coat of Pimento, and lightly distress. Sand all other surfaces.

Trace the design and apply to the top of the box all shapes other than horses and figures.

PAINTING THE IMAGE

Paint the sky in Midnight Blue, then add a little White into the Midnight Blue and blend up a lighter tone behind the buildings, using a dry brush technique. All shapes need to be blocked in base colours which are

darker than they appear in the painted project to allow for the later addition of highlights. Block in the following shapes with the colours indicated:

1 **Building on Left**
Building: Black with just a little Raw Sienna and White added
Windows and Doors: Black
Roof: Vermilion

2 **Central Buildings**
Buildings: Raw Sienna and Cadmium Yellow, Red Oxide (3:3:1)
Roofs: Midnight Blue with a touch of White added
Doorway: Red Oxide and Burnt Umber (1:1)

3 **Centre Hill and all Pathways:** Burnt Umber and Red Oxide (1:1)

4 **Buildings at Back on Right Side** (Green)
Buildings: Pine Green, Raw Sienna and White (5:1:1)
Roofs: Cadmium Red
Windows: Black

5 **Front Buildings on Right**
Buildings: Red Oxide, Raw Sienna and White (2:2:1)
Roofs: Midnight Blue, Black and White (2:1:1)
Windows and Door: Burnt Umber

6 Tall Hill and Embankment on Left including grass area and grassed area across foreground: Raw Sienna and White (4:1)

7 Trace on all detail on hills and foreground.

8 Paint all embankments Burnt Sienna except the face of the central embankment to the left behind the horses. Paint that in Burnt Umber.

9 Mix Raw Sienna and White (2:1) and dry brush across the hill, under the centre buildings. The top of the hill is lighter than down near the embankment.

10 Highlighting the Building:

Except for the red roofs and green building on the right, all walls and roofs of the buildings are highlighted by adding White to the original base colour.

The walls of the green building are highlighted in a mixture of Antique Gold and White. Highlight the red roofs with a mixture of Vermilion and White.

The technique used for highlighting is dry brushing, starting with a mid-tone and then adding a lighter tone on top (refer to Dry Brushing

in General Painting Techniques, Chapter 2). As you are dry brushing, keep in mind that the light is coming from the left so some of the shapes will be a little darker on the right side.

Outline the buildings as follows:

Building on Left: Black
Building in Centre: Red Oxide
Roof: Midnight Blue
Building at Back/Right: Black
Roof: Run Vermilion and White curved stripes over long roof
Building Front/Right: Red Oxide

11 Mix Burnt Umber with a little Raw Sienna and White and dry brush down the front of the embankment, i.e. directly behind the horses. Leave some of the Burnt Umber base colour so as to give depth to the folds of rock.

12 Mix Raw Sienna, Burnt Sienna and White (1:1:3) and dry brush along all the small embankments, again leaving some of the original colour still showing to indicate the undulating nature of the rocks (refer to picture).

13 Dry brush all the grassed areas in a mixture of Pine Green, Antique Gold and White (1:1:1). Add a little extra White to the mixture and brush on a few highlights around the edges of the central grassed area.

To this central area also, add a few little strokes in Hookers Green, concentrating particularly around the top embankment.

14 Make a mixture of Raw Sienna and White (1:3) and paint the top of the rock that juts up and dominates the left side.

When dry, float Raw Sienna lines down as indicated on the pattern.

15 Likewise, float Burnt Umber lines down the underside of the same rock.

16 The top of the rock on the right is dry brushed in Raw Sienna and White (1:3).

17 Outline all rocks in Burnt Umber.

18 The trunks of the trees are painted in Burnt Sienna and White (1:1) and outlined in Burnt Umber. The foliage is Hookers Green dabbed on, followed by a few strokes of Antique Gold as highlights. The shadowy trees against the sky on the left are painted in Midnight Blue.

19 Paint little Burnt Umber dots/strokes along all pathways to represent tiny rocks and pebbles.

20 Trace on all horses, the donkey and figures.

21 The grey horse and donkey are painted in Black and White (1:1). Brush on some lighter highlights and outline in Black.

22 The brown horse is painted in Raw Sienna/Burnt Sienna/White (1:1:3). Brush on some lighter highlights and outline in Burnt Sienna.

23 Paint all faces and hands in White, with a touch of Raw Sienna and Terracotta. Paint on features and outlines in Burnt Umber.

24 *Man, Centre Left*
Shoes & Stockings: Black and White (1:3) Outline in Black
Blanket Roll and Hat: Black and White (1:3) Outline in Black
Garments: Burnt Sienna and White with some lighter highlights and outlined in Black

Man, Centre Right
Garment: Cadmiun Red with White collar and cuffs
Hat: Burnt Sienna and White (1:1)

Lower Figure: Burnt Umber and White (2:1)

Man, Lower Right
Hat and Stick: Burnt Sienna
Garment: Pine Green, White (3:3) with a touch of Midnight Blue Outline in Black
Pack on Donkey: Burnt Sienna and White (1:3) Outline in Burnt Umber

Man, Lower Left
Hat: Black and White (1:3) Outline in Black
Shoes and Stick: Burnt Umber
Stockings: White. Outlined in Black
Garment: As for man lower right
Parcel on Stick: As for pack on donkey on lower right

25 Lettering around Box. Trace the lettering to suit and fit your piece of timber. Paint it in Midnight Blue.

26 Antique, varnish and wax.

7

MINSTRELS, MADRIGALS, & MAYPOLES

Music & Dance

in the Middle Ages

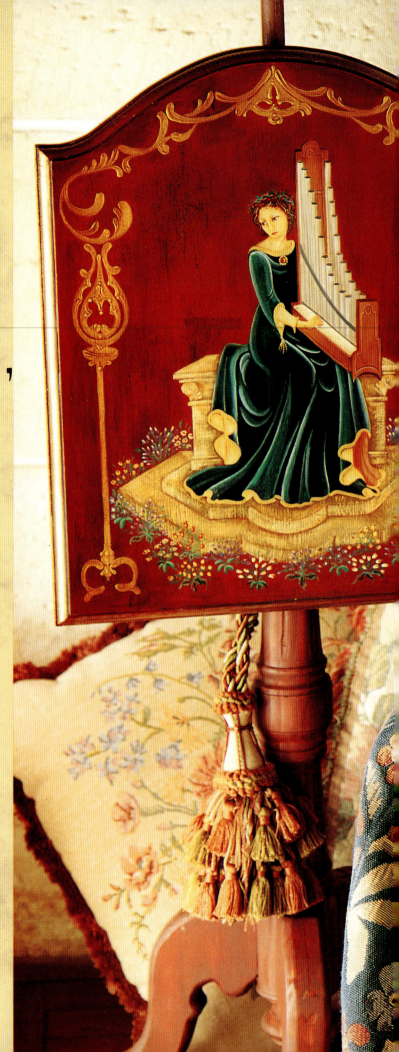

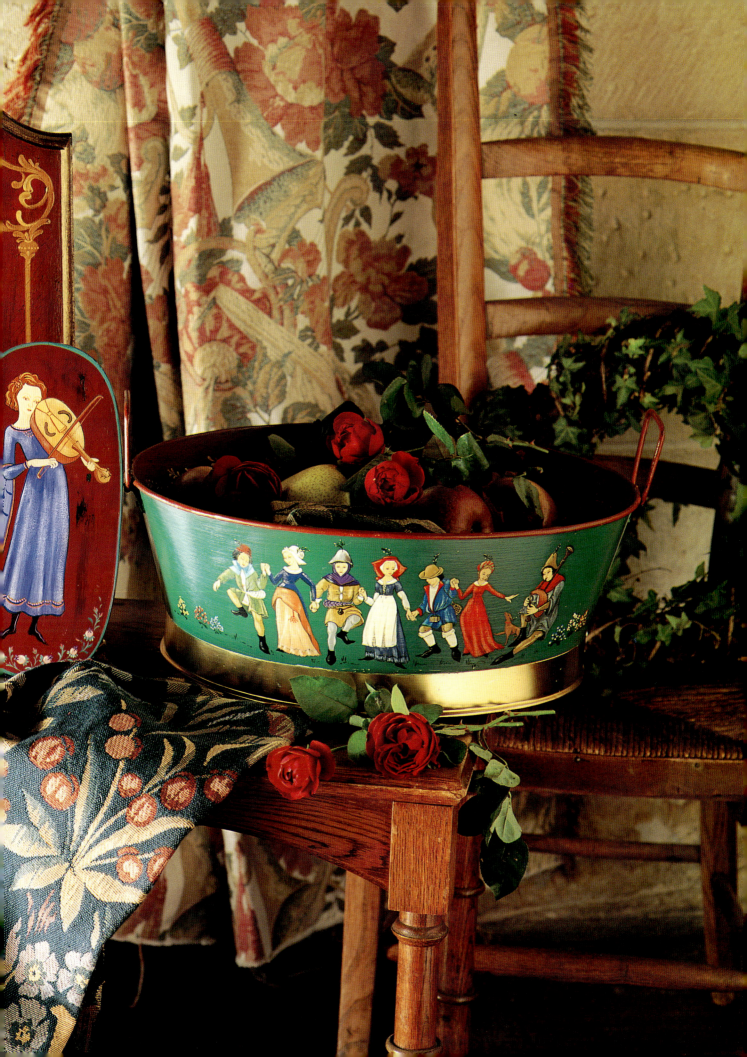

In a society that had neither books nor general literacy, oral tradition was crucially important. Consequently, the people who could, with voice and instrument, bring news or tell of events in a dramatic way, enjoyed almost universal popularity, despite all the attempts of Church and civil authorities to stop them. Minstrels, jongleurs and troubadours featured quite prominently in mediaeval society, in entertaining the great at court and in the manor, and the ordinary folk in public places and public houses. They told of universal things, such as love fulfilled and unrequited, virtue and valour, kindness and compassion. They gave the news of the day — and the scandals of the day. They provided moments of diversion from the ordinary preoccupations of daily life, and helped all to celebrate the particular and recurring joys of living.

As a measure of the importance of music in mediaeval times, it was seen to be one of the accomplishments of people of standing, particularly women. The Muse of Music was often represented as the female figure playing an instrument, as is the case in one of our projects.

For ordinary people, farmers and townsfolk alike, music and dancing were linked to their enjoyment and celebration of the seasons and events of life; the arrival of spring, weddings, births, successful harvests.

The projects proposed in this chapter are:

✠ LADY PLAYING A VIOLIN
✠ SEATED LADY MUSICIAN
✠ MAY DAY DANCERS

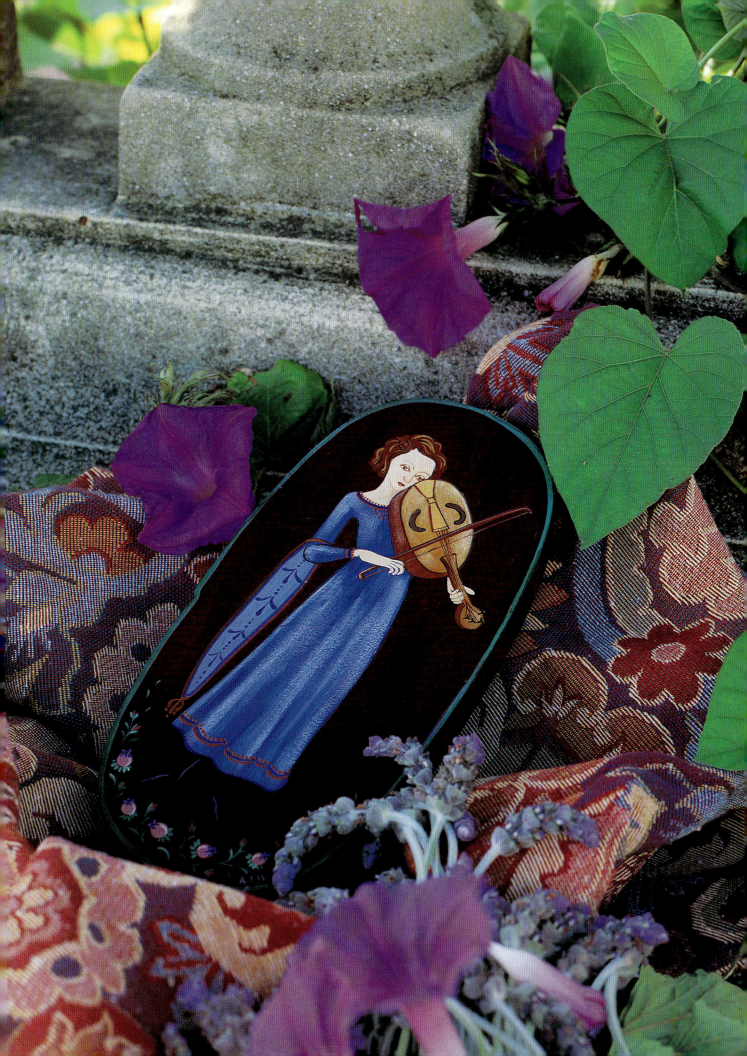

LADY PLAYING VIOLIN

~

In sweet Music is such art,
Killing care and grief of heart.

SHAKESPEARE
Henry III

THIS LITTLE FIGURE displays the love of music in mediaeval times. The figure is from a French illuminated manuscript and is characterised by the gentle swaying 's' shape, typical of the late Gothic style. It is adapted from a painting in a fourteenth century French manuscript from the Angevin Court.

It is a joyous little figure and I feel sure you will enjoy painting it.

Degree of Difficulty - 1

MATERIALS

Small, longish oval box, 260 mm x 120 mm (10¼" x 5")
Background colours: Burgundy, Spruce
Decorative colours: Titanium White, Raw Sienna, Terracotta, Paynes Grey, Red Oxide, Copper, Alizarin, Ultramarine Blue, Spruce, Dioxazine Purple
Brushes: round No 2 and No 3, 7 mm (¼") flat, a liner
Miscellaneous: stylus, Burnt Umber oil paint, patina, satin varnish, wax.

PREPARATION

Background

Give your box one coat of Spruce followed by a coat of Burgundy background paint. Sand well when dry and allow a little of the Spruce to show through.

PAINTING OF THE DESIGN

Faces and Hands

Mix a touch of Raw Sienna and just a speck of Terracotta into White in order to make a nice warm flesh colour. Paint the face and hands with two to three thin coats, allowing drying time between coats.

Dress

Mix Ultramarine Blue with a little White and a touch of Dioxazine Purple (3:2:1). Using your number three, or your flat brush, paint the

dress, giving two coats and allowing time to dry between coats.

Mix a little White into the dress colour and, using a 7 mm (¼") brush and no water, apply highlights by dry brushing (refer to Dry Brushing in General Painting Techniques, Chapter 2), where the top of the folds fall. Brush lightly and allow the underneath colour to peep through.

Inside Sleeve
Paint the colour used for dress highlights.

Decoration on Dress
Neck: outline in straight Ultramarine Blue. Paint a line underneath in Copper and a row of dots above. Paint two half circles of dots in centre front, as appears on the pattern.

Hemline: paint an Ultramarine line around the edge of the hemline and then slightly above, as shown on the pattern. Paint a Copper line below the upper Blue line, and then a row of Copper dots on top.

Sleeve: paint the commas and dots down the centre of the sleeves, as appears on the pattern in the original dress colour mix. Outline round the edge in the same colour, and then in Copper. The commas and dots at the tip of the sleeve are in Copper.

Hair: paint in an equal mixture of Red Oxide and Raw Sienna; line work is in Raw Sienna with White added (1:1) and then outline in Paynes Grey. The hair decoration is in Copper made up of dots and lines.

Stockings: Dioxazine Purple. Paint flat and then add a little White to the Purple and run a line to highlight down one side.

Instrument
Using a No 3 round brush or a 7 mm (¼") flat brush, paint the top of the instrument, using a mixture of Raw Sienna with a little White added (4:1). Add a small amount of Red Oxide to this mixture and paint the side of the instrument. Add a little more White and using your flat brush, lightly brush over the entire surface of the instrument. Paint the 'holes' on top of the instrument in Red Oxide/Raw Sienna (1:1), paint on the strings and pegs in the same colour. Outline the instrument and bow in Paynes Grey.

Face
Trace face on lightly. Float a little watery Red Oxide mixed with White under the chin line and then brush excess down the neck. Mix Raw Sienna with the White and using a liner brush, 'draw' on all lines. Paint the pupil in straight Red Oxide and add a little flash of White to the centre. Paint across the eyelid with a lighter mixture of Raw Sienna and White. Paint lips in Red Oxide.

Hands
Outline the hands in Raw Sienna.

Flowers

The bulbs of the flowers and the buds are painted in Alizarin and White (1:2) and have a little Dioxazine Purple mixed with White for the daisy on the top. All leaves, stems and commas are in Spruce and White.

FINISHING

Allow the paint a couple of days to cure before antiquing. I would recommend only very light antiquing so as not to lose the vibrancy of the blue or the spirit of the figures. Varnish and wax.

SEATED LADY MUSICIAN

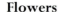

From harmony, from heavenly harmony,
This universal frame began.

DRYDEN,
An Ode for St. Cecilia's Day

Music was greatly loved in mediaeval times at Court and in the lives of common people. The figure represented here is a detail from the manuscript of the treatise by Boethius on Mathematics and Music; the illumination dates from the 14th century and is from the Angevin Court in France.

In these allegorical representations, Music is variously depicted. In this instance, it is represented by a beautiful woman of the Court playing on a portable organ. We note the elaborate care in costume; the elegant colours and flowing garments with long hanging sleeves typify French court fashions of the second half of the century.

Degree of Difficulty - 4

MATERIALS

A screen or plaque. I have painted a pole fire screen, 450 mm x 380 mm, (18" x 15½") used to protect the complexion in front of the fire
Background colours: Turquoise, Pimento
Decorative colours: Raw Sienna, Titanium White, Spruce, White Pearl, Cadmium Red, Burnt Sienna, Burnt Umber, Silver, Black, Dioxazine Purple, Terracotta, Ultramarine Blue, Gold Light, Gold Oxide, Cadmium Yellow

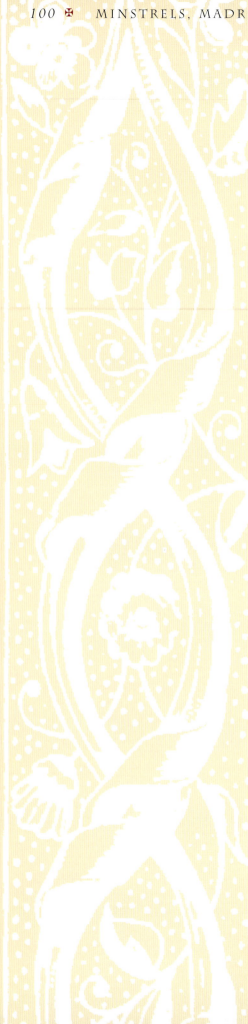

Brushes: flat 7 mm (¼") fine liner, Nos 00, 3 round, background brush
Miscellaneous: stylus, tracing paper, carbon paper, sandpaper, carbothello pencil, crackle medium, Burnt Umber oil paint, patina, varnish, wax.

PREPARATION

With a 25 mm (1") background brush, paint all surfaces in Turquoise. When dry add a little crackle medium, particularly in the area of the seat and dress, and where the image does not appear. When dry, paint on a coat of Pimento. Sand when dry.

PAINTING THE IMAGE

1 Paint in the face and hands in flesh colour and then add the features (refer to Painting Faces and Hands in General Techniques, Chapter 2). The demonstration face shown in General Techniques has been taken from this project.

2 Block in the following shapes in the colours indicated. The stone pedestal seat should be painted with a little extra texture.

Seat: Raw Sienna (2-3 Coats)
Framework of Organ: Burnt Sienna, Raw Sienna and Pearl (3:1:2)
Organ Pipes: Silver, Burnt Sienna, Burnt Umber, White (4:1:1:2)
Organ Keys: White, with a touch of the mixture above
Undergarment: lower right side – Gold Oxide, Gold Light (2:1)
Lining of Dress: Gold Light and White and Raw Sienna (3:2:1)
Dress: Spruce and White Pearl (3:1)
Hair: Burnt Umber

3 Make a dry mixture of Raw Sienna and White (3:1) and, referring to the colour picture and the dry brushing instructions in General Painting Techniques, Chapter 2, dry brush the seat and its base. Add some extra White and add a lighter tone along edges and high points. Outline in Raw Sienna with a fine liner brush.

4 Mix some extra White Pearl into the organ frame mixture and dry brush down the front end of the frame and a little at the top.

5 Using this same mixture, paint on the lines on the pipes and keys.

6 Float an edge of Gold Light down the front of the underskirt (right-hand corner of skirt).

7 Mix Gold Light and White (2:1), add a touch of Gold Oxide and dry brush on a deeper tone to the lining in the areas close to the top of the

fold that would have a shadow created by the overhanging of the skirt above. Dry brush the lower edge of the sleeve with the same colour. Define the lining folds with a fine line of Gold Oxide.

8 Trace on the folds of the dress. Follow the colour picture and paint on the fold by running a sideload of White Pearl along the edge of each fold, either side of the arm, across the shoulder and down the hip.

9 Paint a nice thick Gold Light line, approximately 3 mm ($\frac{1}{8}$") thick, around the edge of the skirt, the edge on the sleeve of the top and undergarment, and around the neck. Apply the tassel on the sleeve in Gold Light with a stylus.

10 Paint jewel at the neck in Cadmium Red outlined in Gold Light, surrounded by Gold Light dots.

11 Paint the lines in the hair in fine Gold Light lines.

12 Paint the little leaves in the hair in Spruce and White Pearl (2:1) and the berries in Cadmium Red.

13 Paint the flowers by following the guide in General Painting Techniques, Chapter 2.

14 Trace on the pattern for the gold filigree that frames the figure. Paint in Metallic Gold. All commas are heavily loaded textured ones.

15 If you are painting a pole screen, paint the routed edge in a mixture of Spruce and White Pearl (3:1). Follow with a coat of Gold Light when dry. Distress so that the Pimento and Spruce show through.

16 You might like to write the name and origin of the painting on the back and perhaps decorate with a few of the field flowers.

17 Antique, varnish and wax.

MAY DAY DANCERS
~

Sumer is icumen in
Lhude sing! Cuccu
Groweth sed and bloweth med
and springth the wude nu
Sing Cuccu.

Spring has come
sing loudly cuckoo
The seed is growing
the meadow is in flower
and now the woodland is coming into leaf
Sing Cuckoo.

ANON

ILLUSTRATIONS OF GROUPS of dancers abound in mediaeval art. The people represented are more often, though not exclusively, peasants and the dance is usually in the form of a ring or round.

As celebrations of the arrival of spring, of youth and youthful love, of the joy of living, of casting off the repression in their lives, (significantly that of the Church) these dances were immensely popular and were held outdoors, in castles, often in churchyards. The very opposition of the Church probably added to the sense of fun and freedom that marked them. Some of the best records of the time are those of the Church's attempts to forbid dancing and revelry, as when the Bishop of Worcester tried to prevent the traditional May Day festivities in which a village girl was chosen as Queen of the May and was to be crowned with a garland of flowers.

The Ring dances and the May dances, with their mixture of ordered movement and joyful celebration, typify the dances that appeared in the later Middle Ages and promoted one mediaeval writer to comment, 'Dancing is therefore for the good of a well-ordered society, apart from the pleasure the act of dancing itself may give to those who perform it'.

Degree of Difficulty - 3

MATERIALS

Oval tinware dish or long plywood box. Length of design measures 300 mm (12")

Background colours: Spruce, Pimento

Decorative colours: Black, Titanium White, Hookers Green, Phthalo

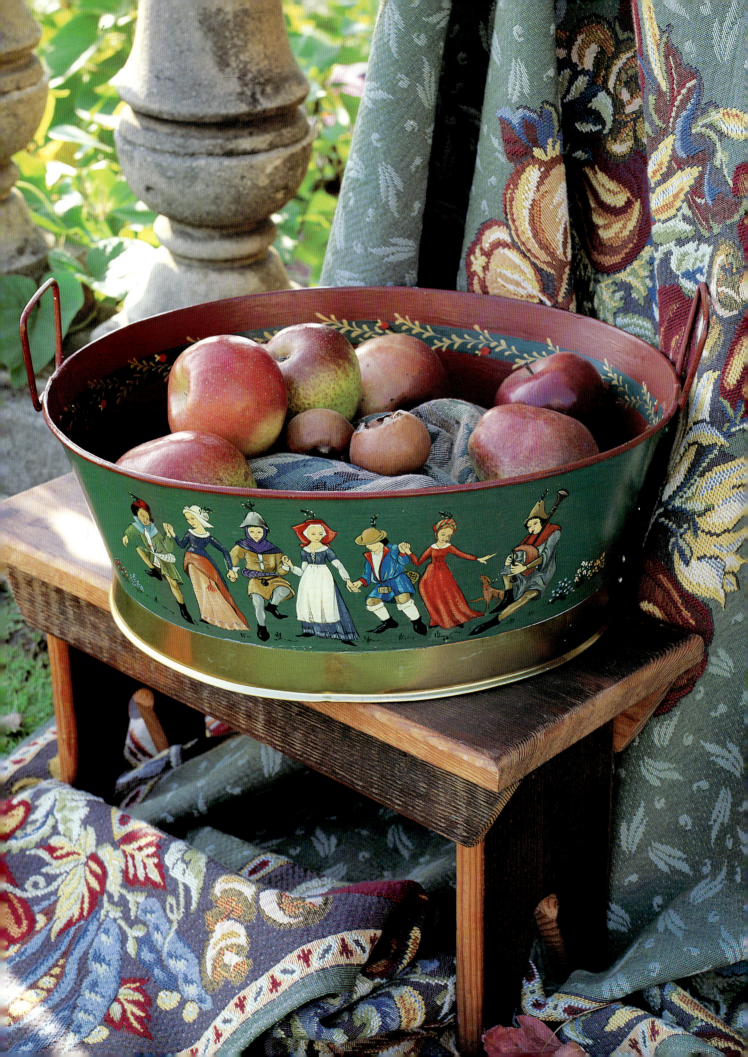

Green, Phthalo Blue, Ultramarine Blue, Midnight Blue, Naphthol Crimson, Dioxazine Purple, Burgundy, Raw Sienna, Metallic Gold, Terracotta, Cadmium Yellow, Burnt Sienna, Cadmium Red, Red Oxide
Brushes: Nos 00, 2, 3 round, fine liner, 25 mm (1") background
Miscellaneous: tracing paper, carbon paper, stylus, satin polyurethane varnish, metal etching primer, PVA all-purpose undercoat.

Preparation of Tinware

1 Clean tinware by giving a good wipe over with vinegar.

2 Lightly sand.

3 Coat with one application of etching primer for galvanised iron, obtainable from hardware stores and available in White or Yellow.

4 Undercoat with a single application of all-purpose undercoat.

5 Basecoat with two coats of Spruce on the outside and Pimento on the inside. Sand lightly between coats.

Preparation of wood

Give one coat of Pimento to all surfaces of box and apply a little crackle medium 'here and there'. When dry, apply another coat of Pimento to the inside of the box and a coat of Spruce to the outside. Sand well when dry, lightly distressing the surface.

Applying the Design

Trace the pattern and apply it to the surface. When tracing on the tinware you will find that because you are tracing a straight design onto a curved surface you will need to trace on the centre figure first and then lift the design just very slightly as you trace each following figure. Trace all figures on the right first, followed by those on the left.

Painting the Image

1 Paint all faces and hands (refer to Painting Faces and Hands in General Techniques, Chapter 2). Using a 00 round brush, outline all features in Burnt Sienna. Paint in the pupil also in Burnt Sienna and add a little flash of White to the centre. Paint in the lips in Terracotta. Outline the hands in Burnt Sienna.

2 Paint all shoes Black.

3 Starting from the figures on the left, block in all the following shapes in the colours indicated:

Figure 1

Undergarment and Bag: White
Undergarment Stripes: Cadmium Red
Hair: Black
Hat: Cadmium Red
Collar: Phthalo Blue and White (1:1)
Tunic: Hookers Green, Raw Sienna, and White (2:2:1)

Figure 2

Hat and Collar: White
Bodice & Top of Skirt: Ultramarine Blue with a touch of Black and White
Skirt Turnback: Terracotta and White (3:1)
Underskirt:: Terracotta and White (1:1)

Figure 3

Hair: Black
Cape and Bag: Dioxazine Purple and White (3:1)
Hat & Stockings: Black and White (1:1)
Cuffs and Underskirt: White
Tunic: Raw Sienna and White (3:1)

Figure 4

Dress: Ultramarine Blue with a little Dioxazine Purple and White added
Under Hat, Collar, Sleeves: White
Apron and V Shape: (at front of bodice) White
Hat: Cadmium Red

Figure 5

Hair: Black
Hat and Stockings: Raw Sienna and White (3:1)
Under Sleeves: Raw Sienna and White (3:1
Tunic: Phthalo Blue and White (3:1)
Collar and Cuffs: Cadmium Red

Figure 6

Hat: Cadmium Red and Green from Figure 1, painted alternately
Dress: Cadmium Red
Collar: White

Figure 7

Hair: Black
Hat & Stockings: Raw Sienna and White (3:1)

Under Sleeves: Raw Sienna and White (3:1)
Tunic: Black and White
Collar: Cadmium Red
Bagpipes: Pipes – Burnt Umber; Bag – Terracotta
Dog: Red Oxide with Cadmium Red Collar
Twigs In Hats: Phthalo Green with a touch of White added
Leaves on Field Flowers: Phthalo Green with a touch of White added

Highlights

Taking note of where the highlights fall on the sample picture, (note the light is coming from the left) mix a lighter shade of each colour by adding White to the flat colours. The only exception to adding White to each colour is to add Vermilion to the Cadmium Red so that it does not become too pink. Lightly brush onto each area using a 7 mm (¼") flat dry brush (refer to Dry Brushing in General Painting Techniques, Chapter 2).

The turnback on the apron and shadows on the sleeves of the lady on the right are a paler shade of the dress. Stand back from your painting from time to time while you are brushing in the highlights.

Outlines

Using a liner brush and very fine lines, outline all images with Midnight Blue paint. Paint lines across the bags around the men's waists and lines down the bodice of the dress of the lady on the right.

Flowers

Refer to Painting Field Flowers in General Painting Techniques, Chapter 2.

Decoration inside Dish

Draw a line around the inside of the dish by marking 30 mm (1⅛") from the top all the way around. Measure down 20 mm (¾") from this line. Paint Spruce background paint between the lines. You should have a 20 mm (¾") Spruce ring running around the inside of the dish 30 mm (1⅛") from the top.

If you are painting on a box, this design would look interesting around the lower edge of the base of the box.

Draw or trace on the design and paint as follows:

Leaves: Metallic Gold (use textured commas)
Buds: Cadmium Red with Cadmium Yellow commas at top, leaves and stems and stamens are in Hookers Green

Finishing

This is a lovely vibrant work and by preference I have not antiqued it. Give two coats of varnish.

PROJECT PATTERNS

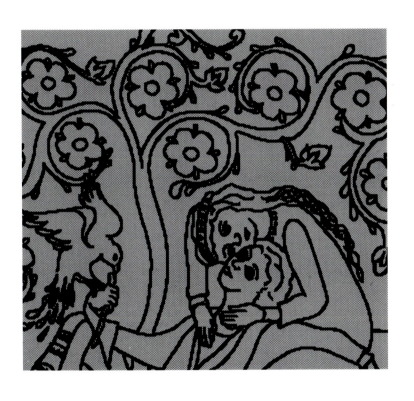

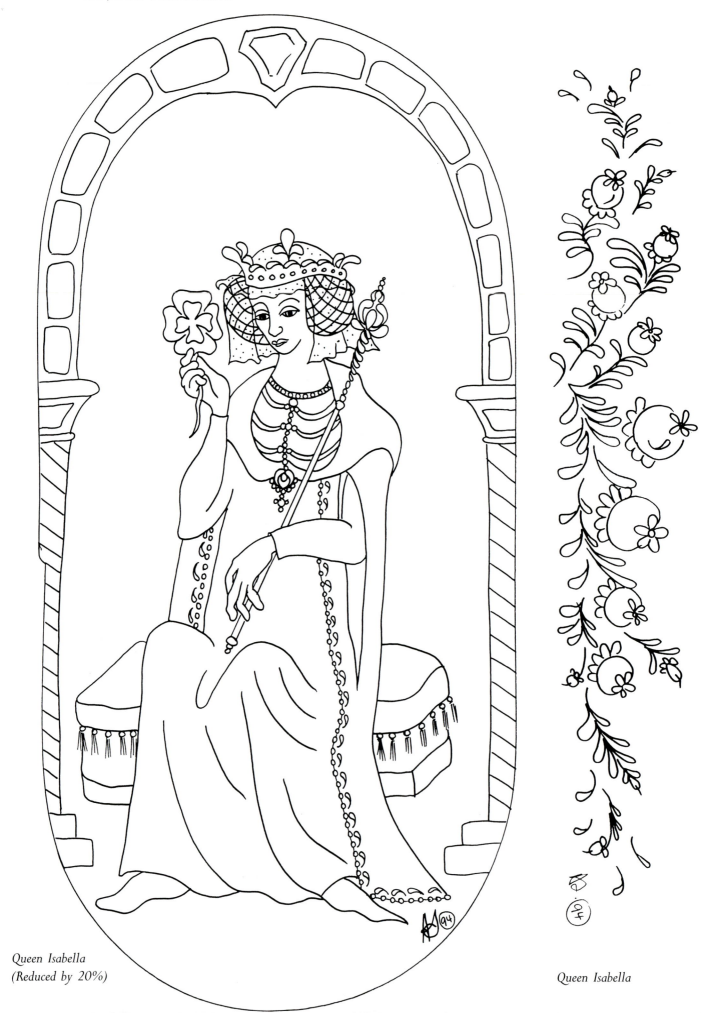

Queen Isabella
(Reduced by 20%)

Queen Isabella

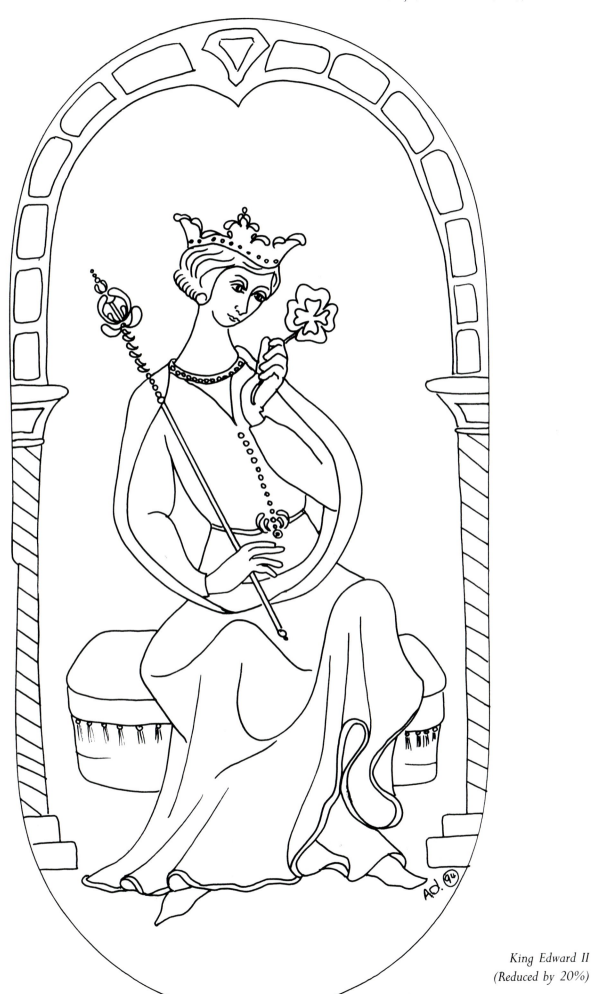

King Edward II
(Reduced by 20%)

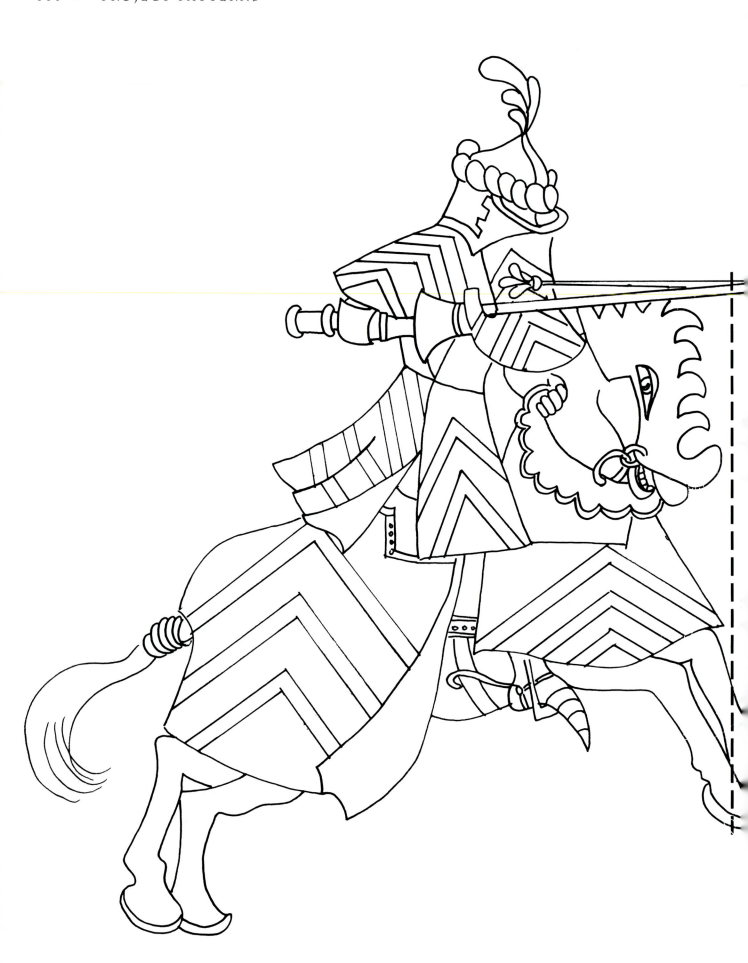

Knights Jousting

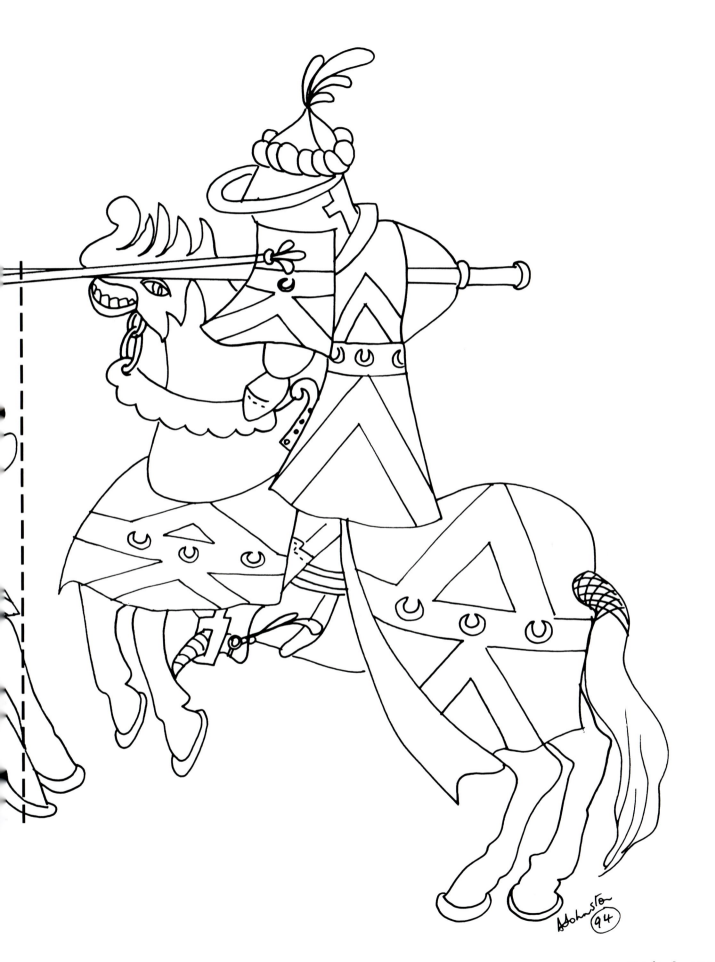

Knights Jousting

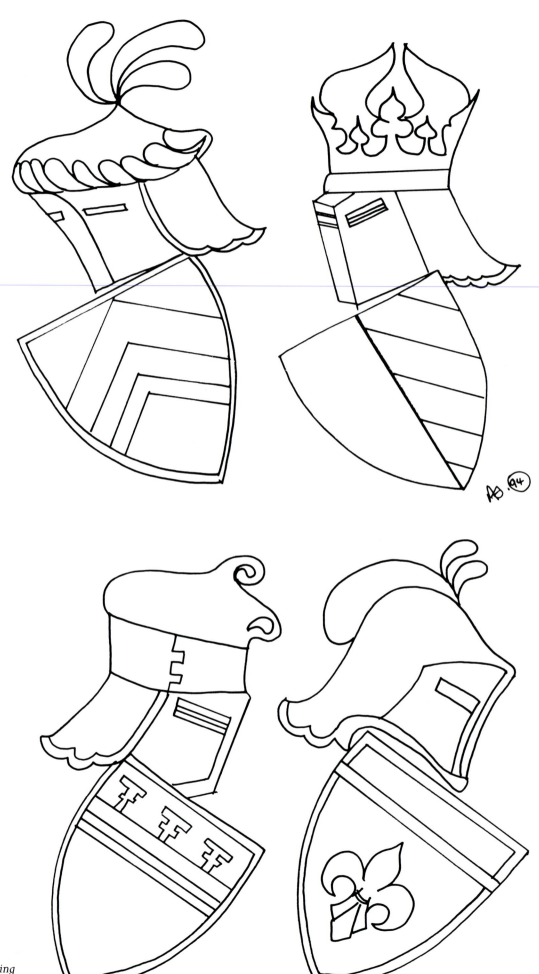

Knights Jousting

Knights Jousting

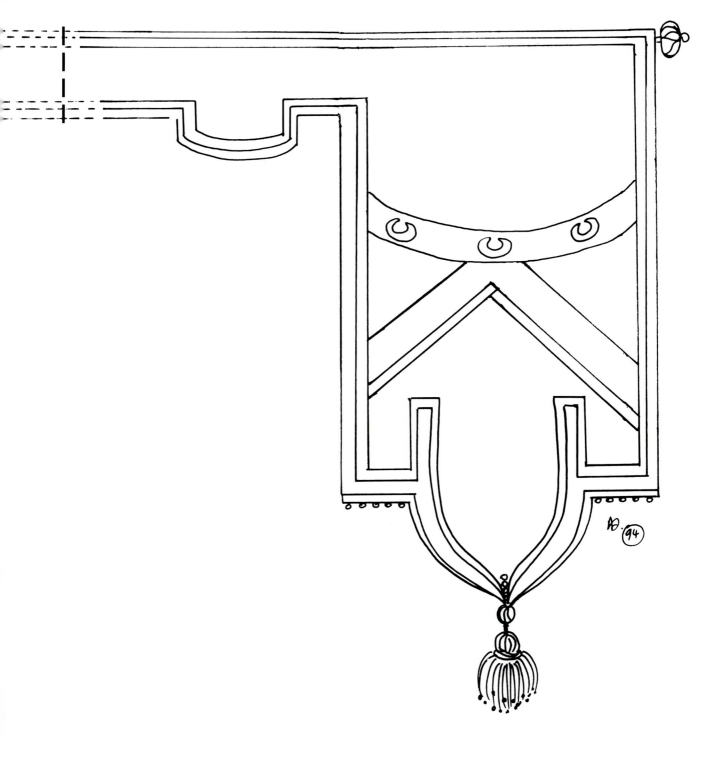

Knights Jousting

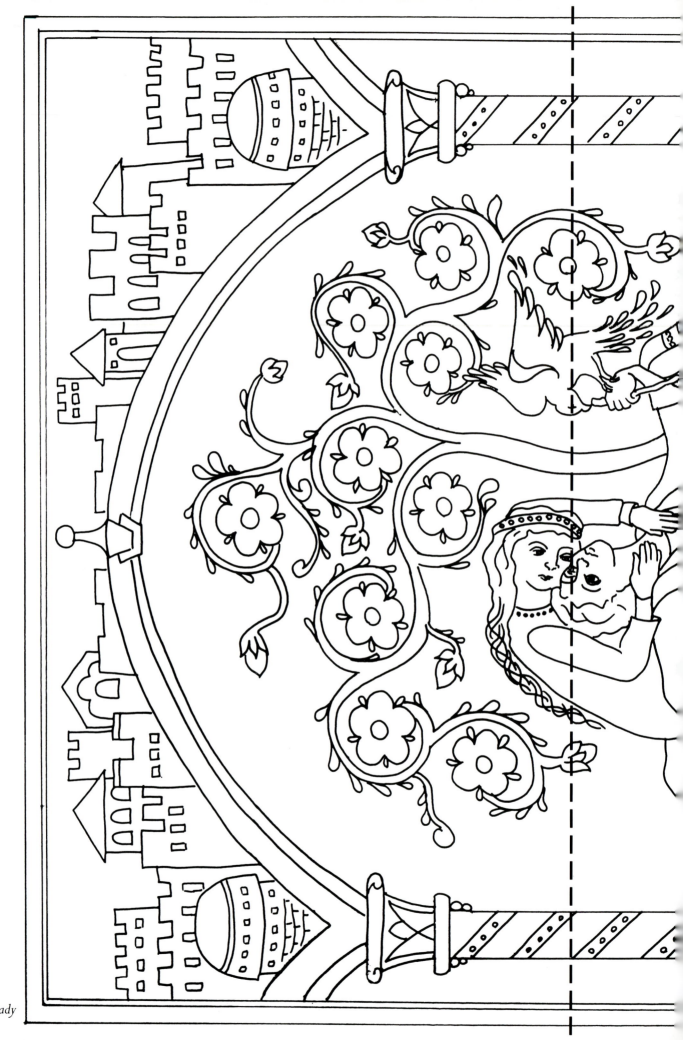

Knight
& His Lady

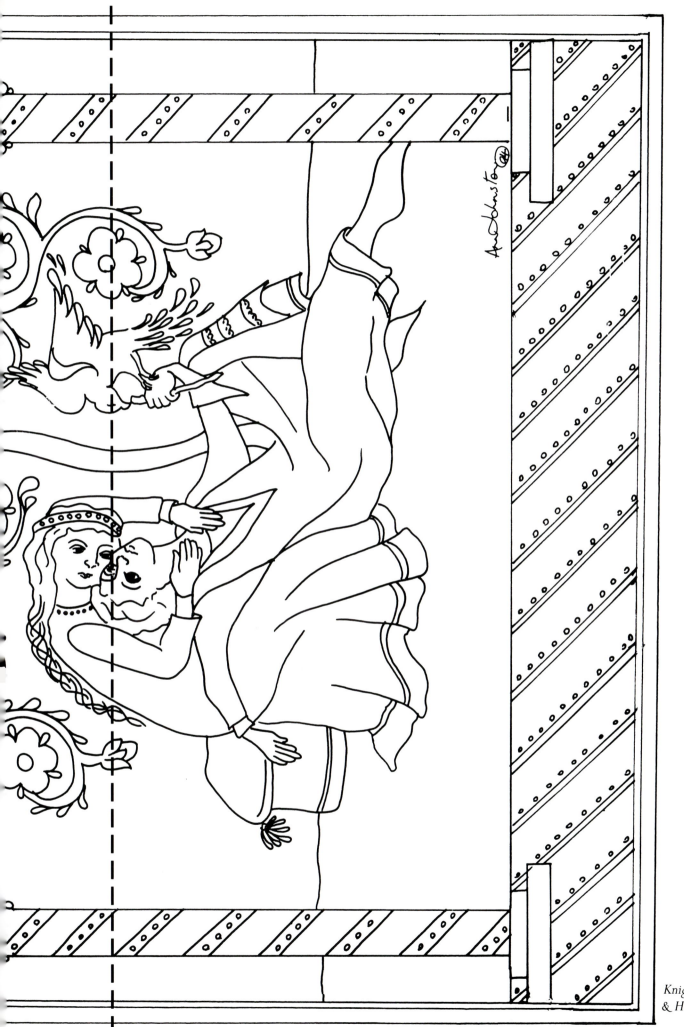

Knight
& His Lady

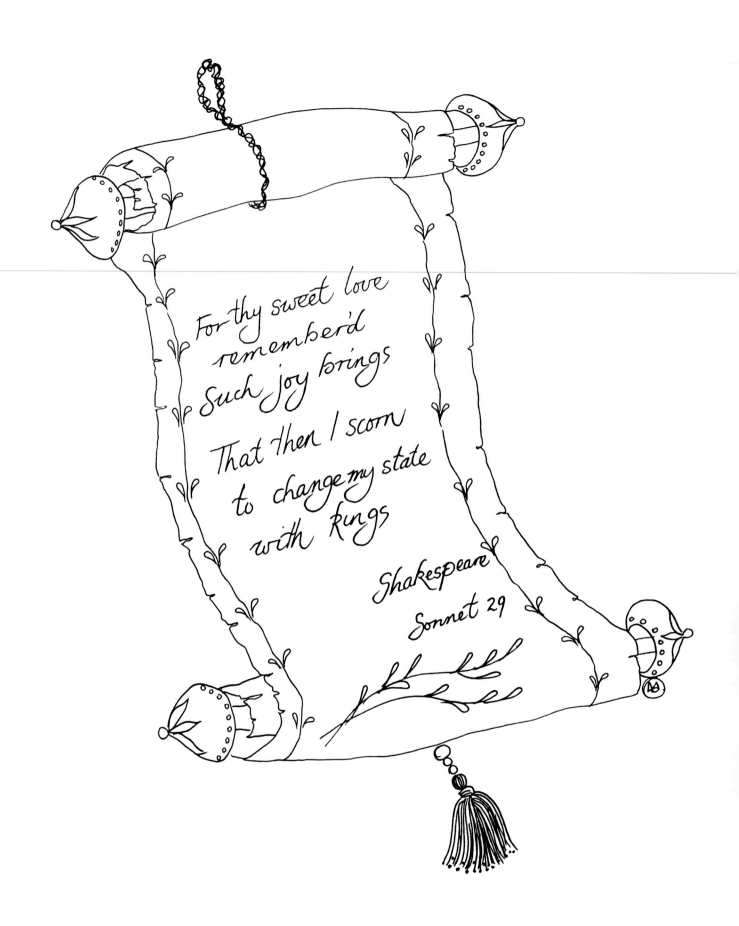

For thy sweet love
remember'd
such joy brings

That then I scorn
to change my state
with kings

Shakespeare
Sonnet 29

Knight & His Lady

Lady & the Unicorn

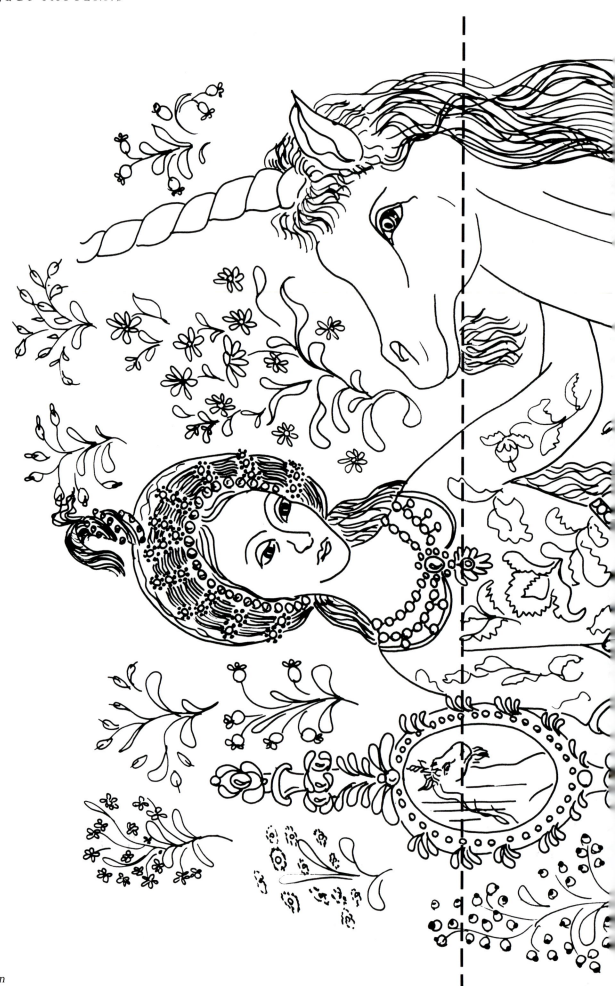

Lady & the Unicorn

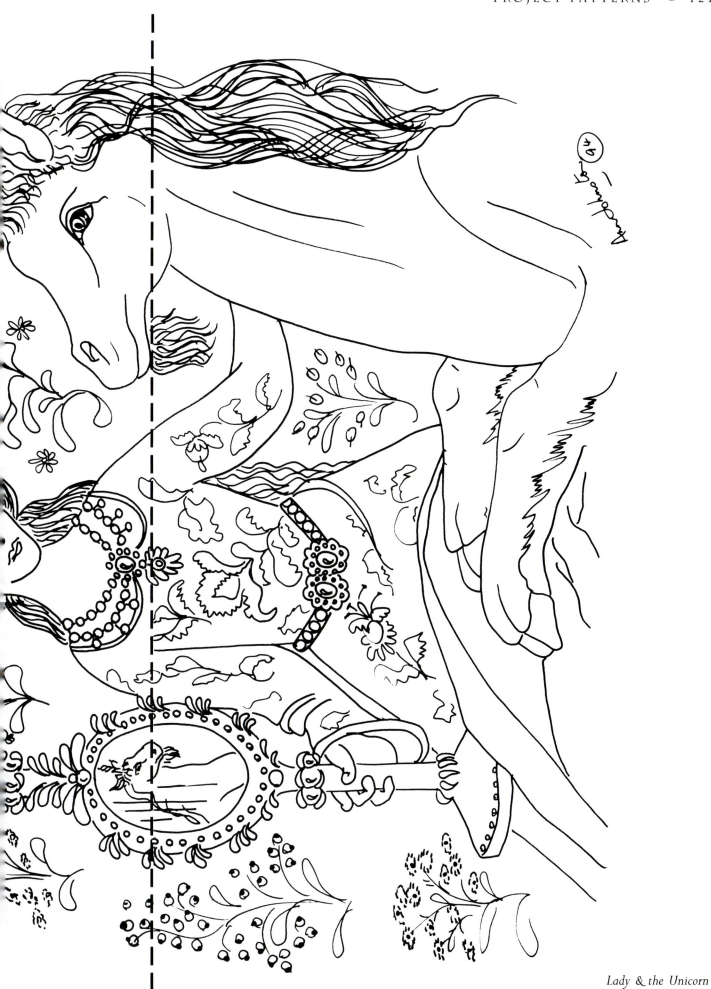

Lady & the Unicorn

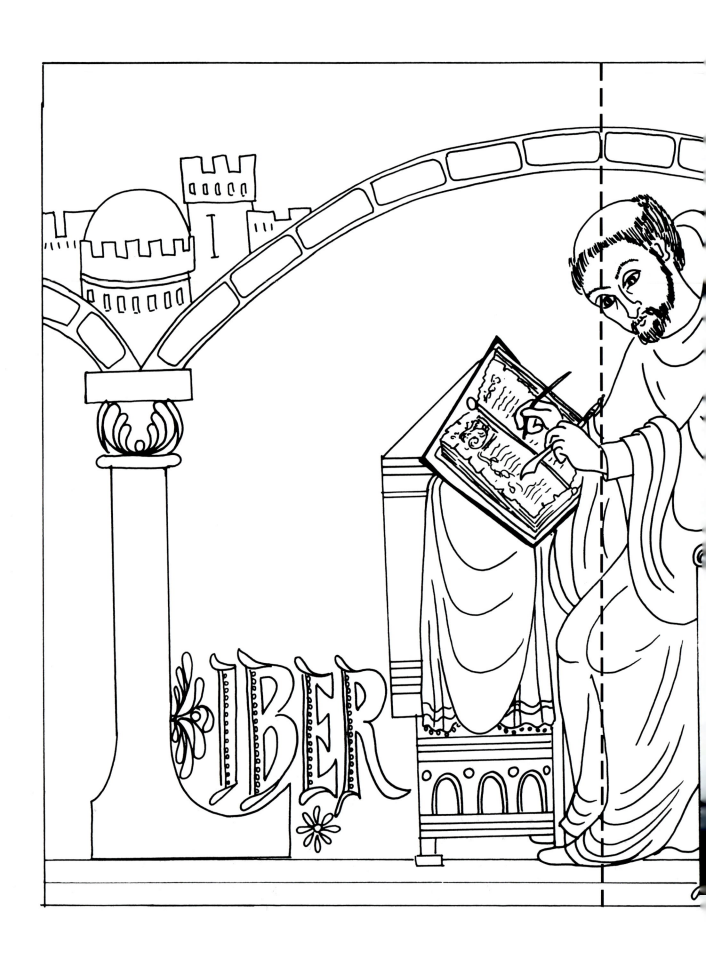

Scribe

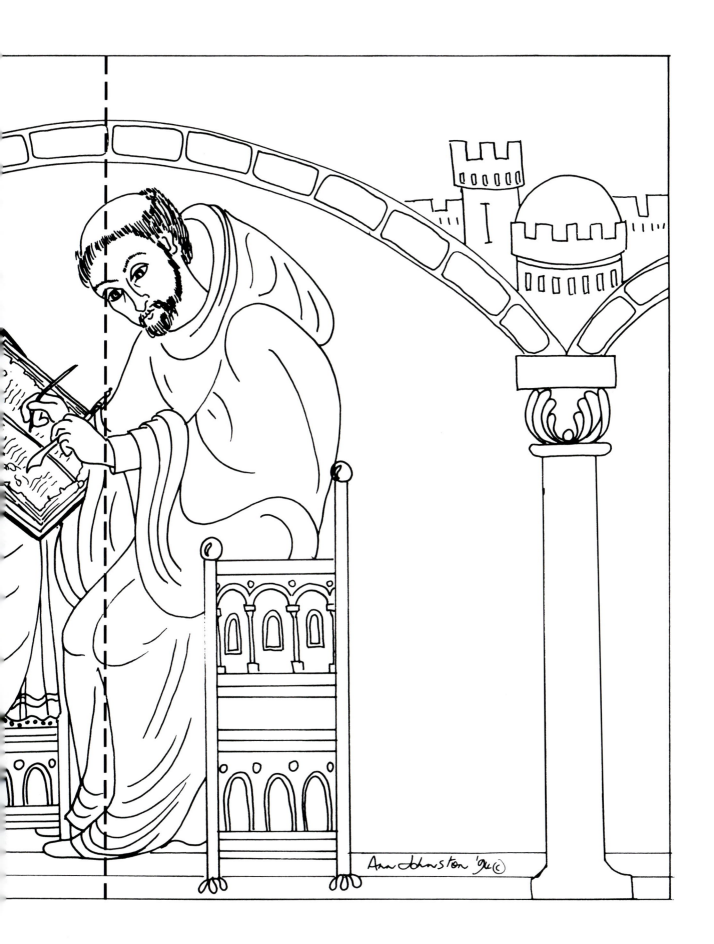

Scribe

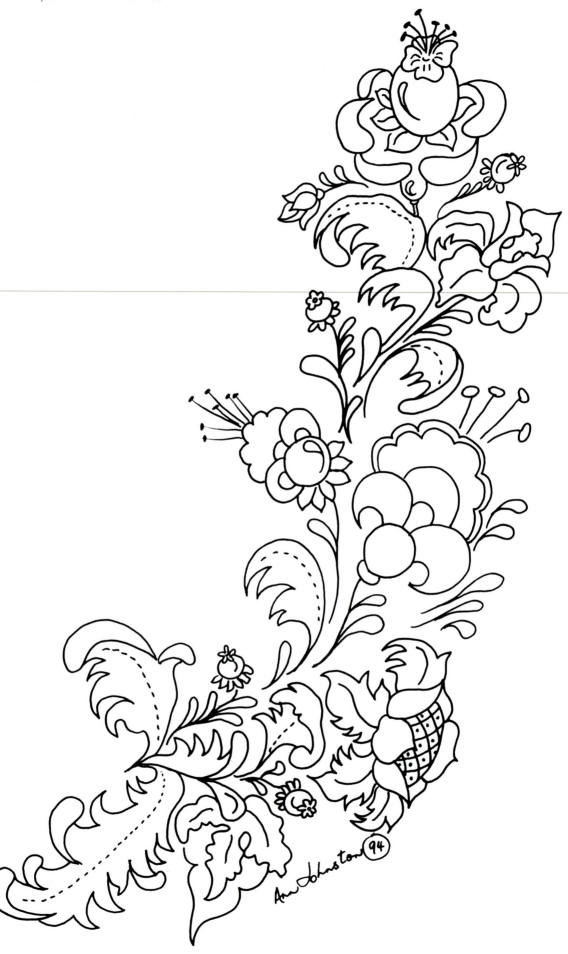

Illuminated Flowers

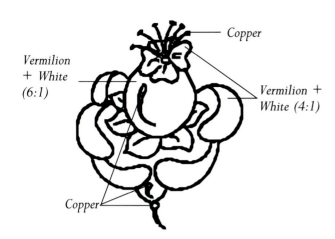

Copper

Vermilion + White (6:1)

Vermilion + White (4:1)

Copper

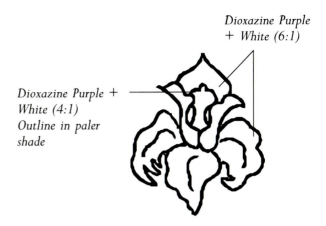

Dioxazine Purple + White (6:1)

Dioxazine Purple + White (4:1)
Outline in paler shade

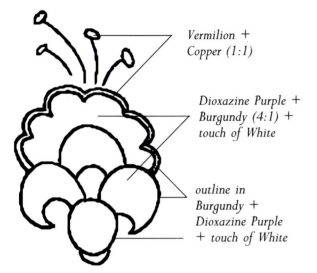

Vermilion + Copper (1:1)

Dioxazine Purple + Burgundy (4:1) + touch of White

outline in Burgundy + Dioxazine Purple + touch of White

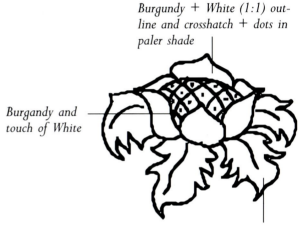

Burgundy + White (1:1) outline and crosshatch + dots in paler shade

Burgandy and touch of White

Dioxazine Purple + Burgundy and touch of White
Outline in deeper shade

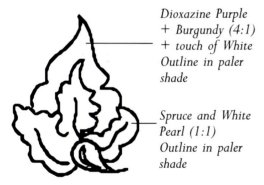

Dioxazine Purple + Burgundy (4:1) + touch of White
Outline in paler shade

Spruce and White Pearl (1:1)
Outline in paler shade

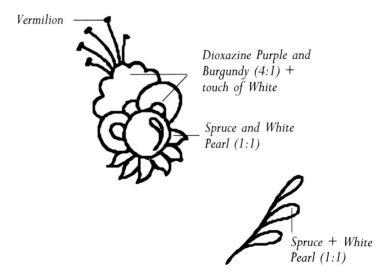

Vermilion

Dioxazine Purple and Burgundy (4:1) + touch of White

Spruce and White Pearl (1:1)

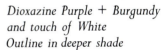

Spruce + White Pearl (1:1)

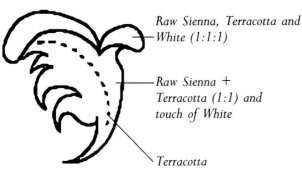

Raw Sienna, Terracotta and White (1:1:1)

Raw Sienna + Terracotta (1:1) and touch of White

Terracotta

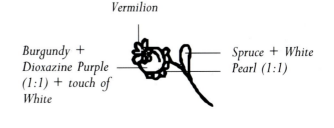

Vermilion

Burgundy + Dioxazine Purple (1:1) + touch of White

Spruce + White Pearl (1:1)

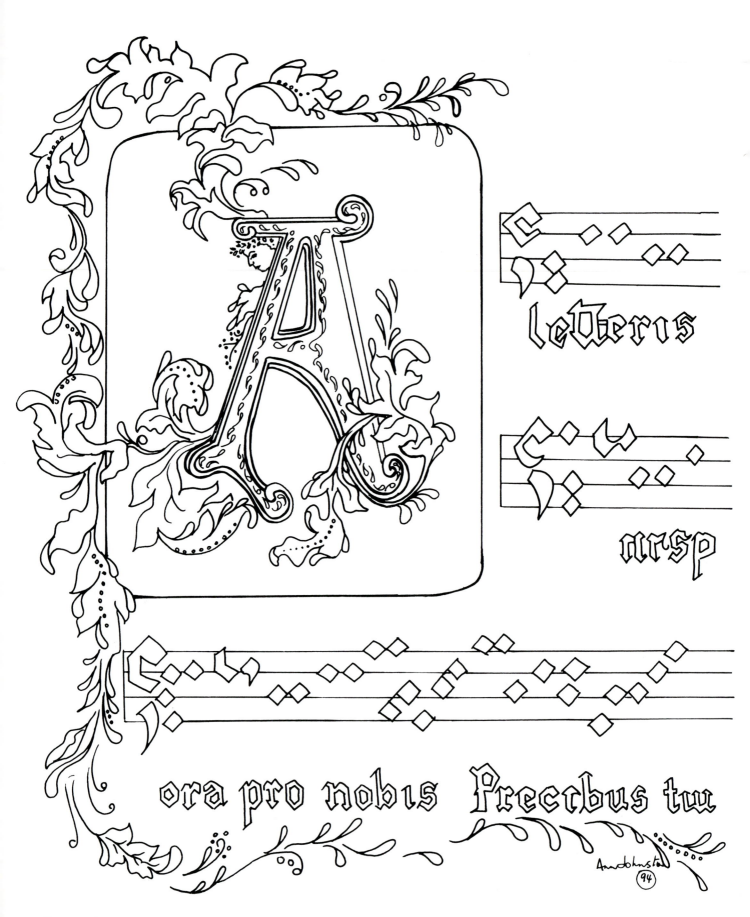

Illuminated Letter
(Reduced by 15%)

Mediaeval Design

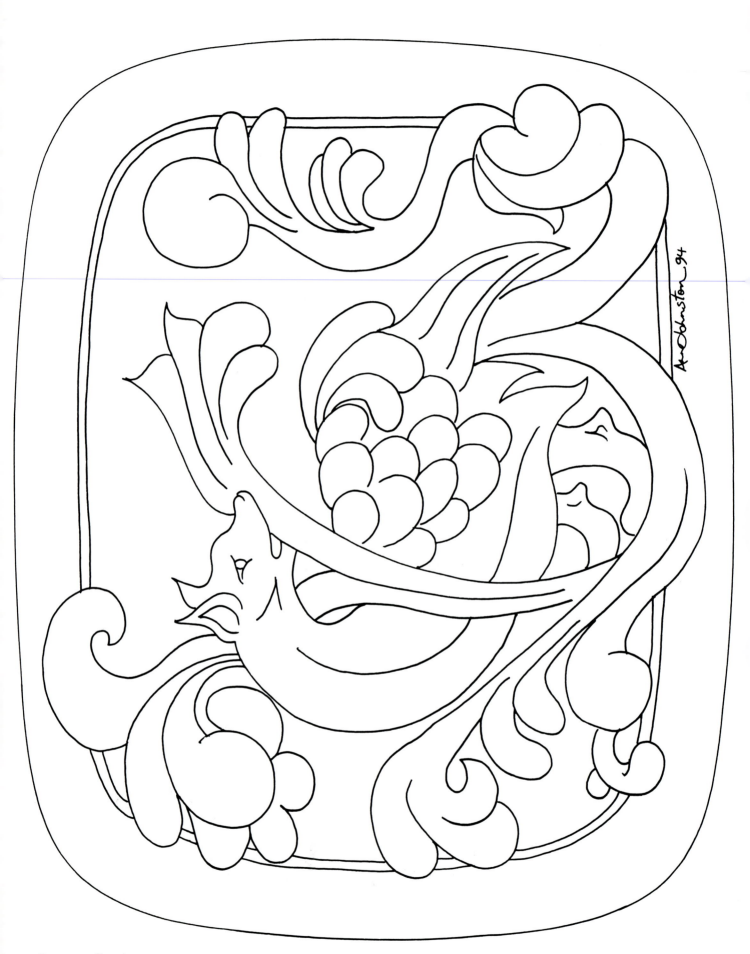

Decorative Dragon

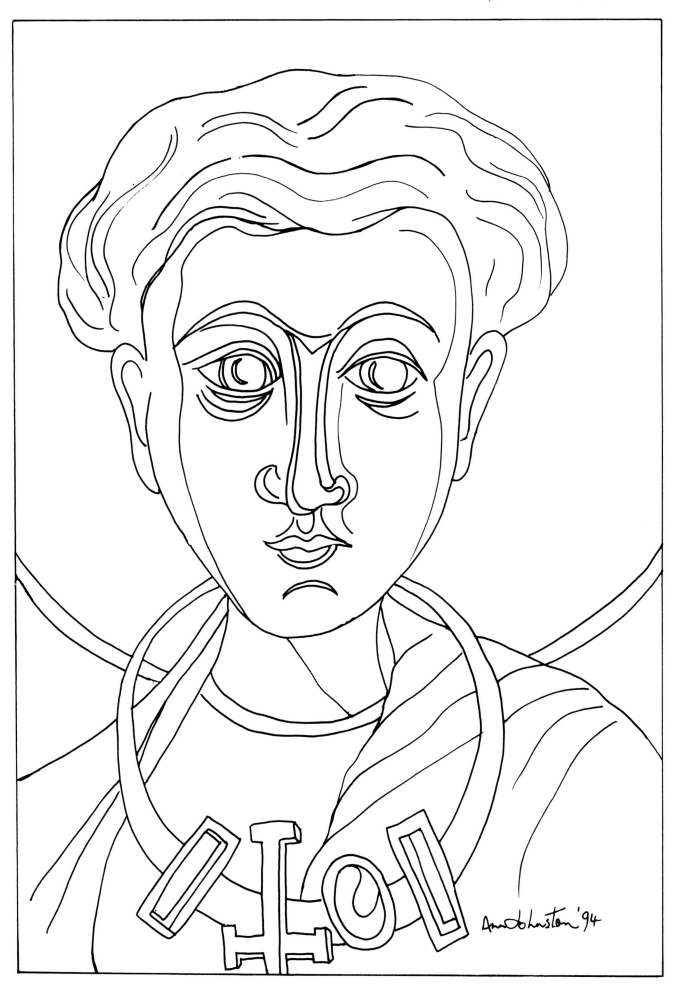

Icon of Saint Phillip (Reduced by 10%)

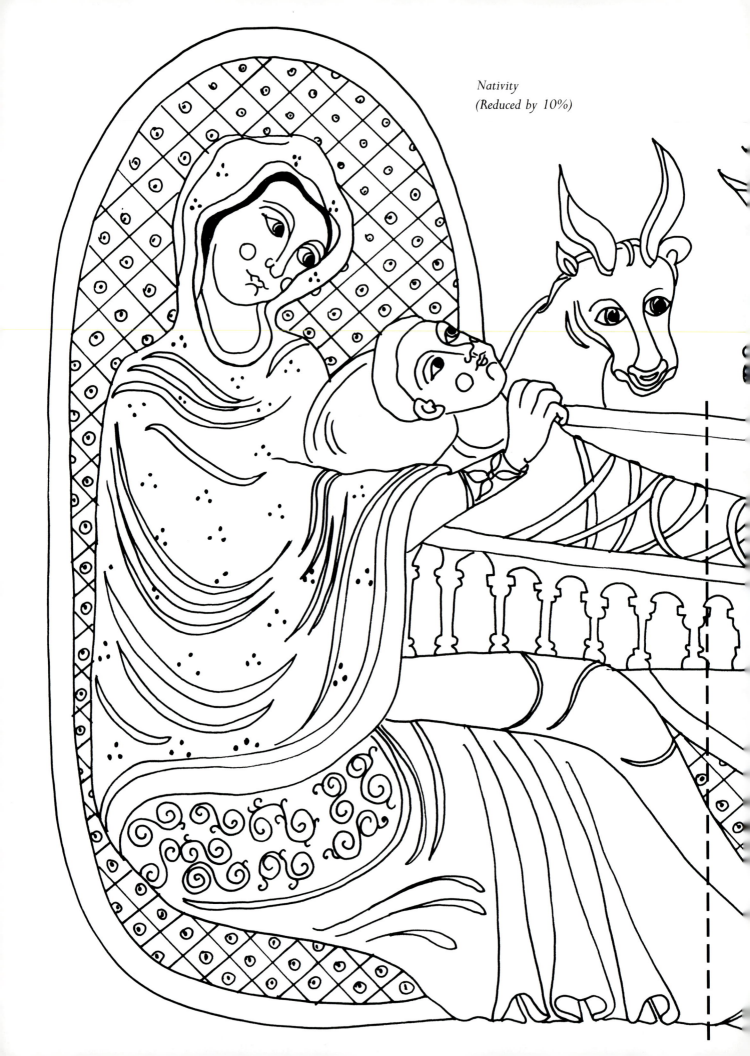

Nativity
(Reduced by 10%)

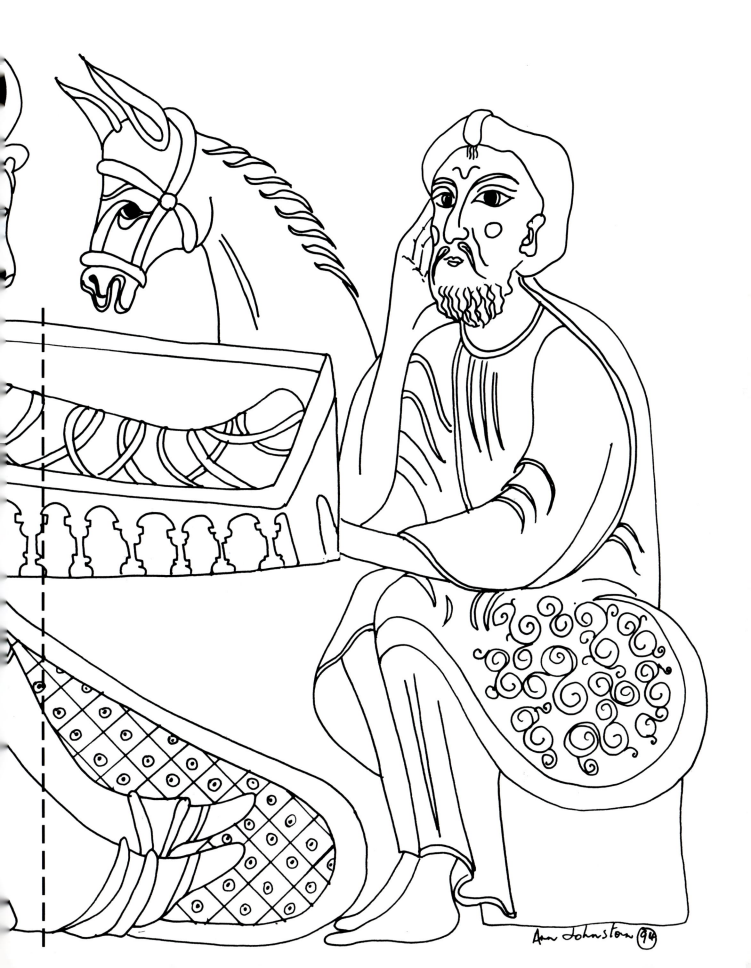

Nativity
(Reduced by 20%)

Nativity
(Reduced by 20%)

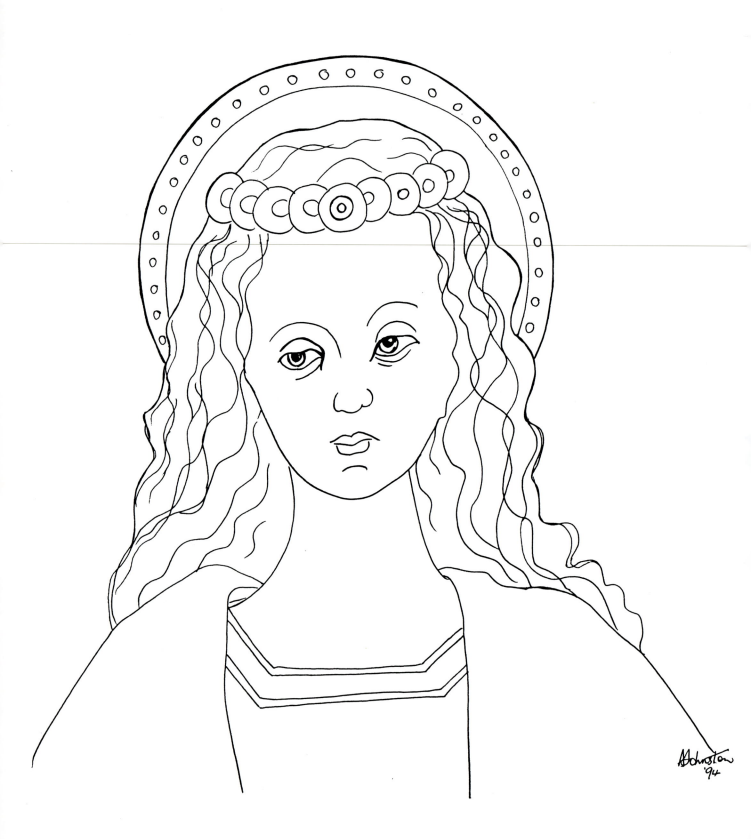

Santa Lucia
(Reduced by 15%)

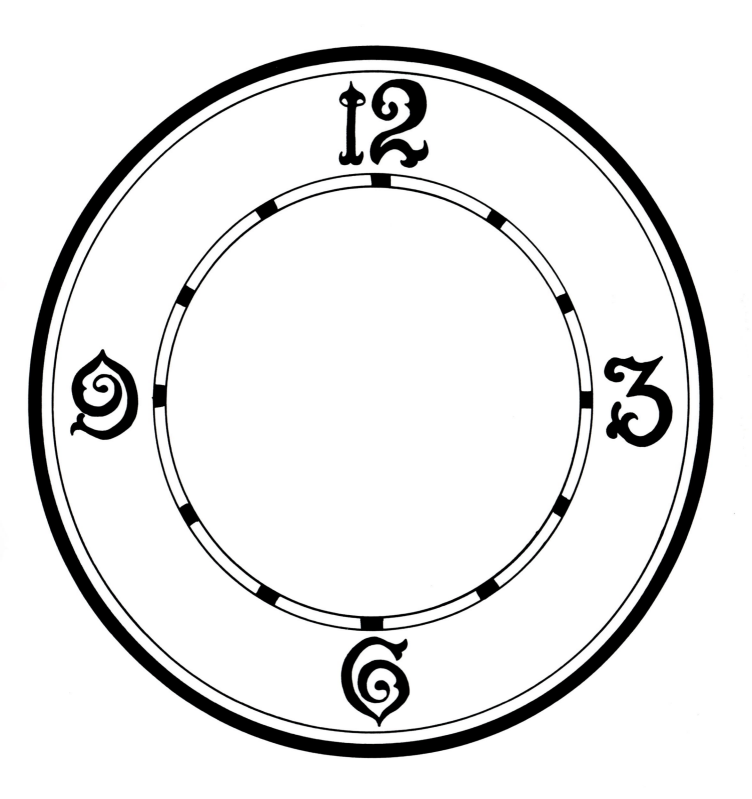

Mediaeval Clock

Mediaeval Clock

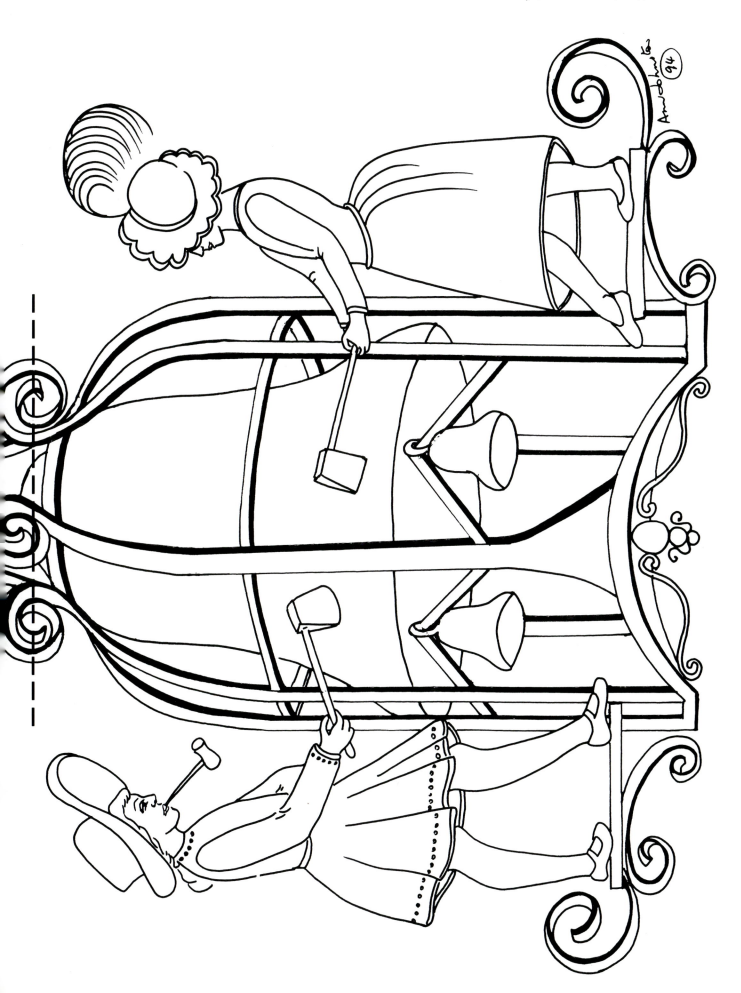

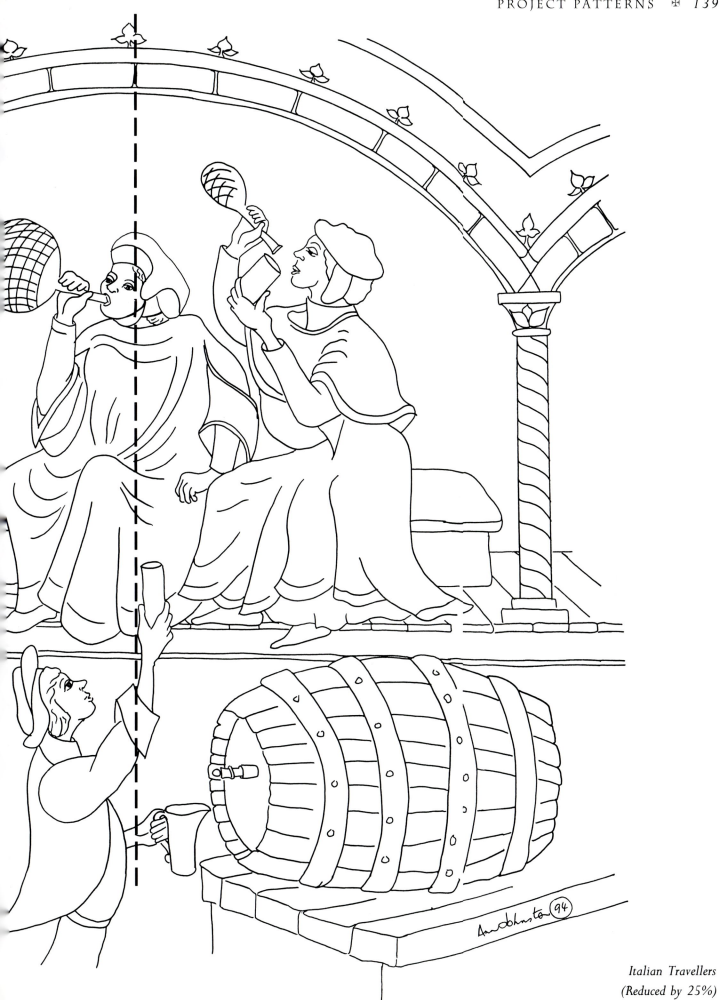

Italian Travellers
(Reduced by 25%)

Marco Polo

Marco Polo

IN THIS CITY HABITH RUNN
BAITH A HUGE LARGE OF
MARBLE AND OTHER
ORNAMENTAL STONE...

From 'The Travels of Marco Polo'.

Marco Polo
(Reduced by 20%)

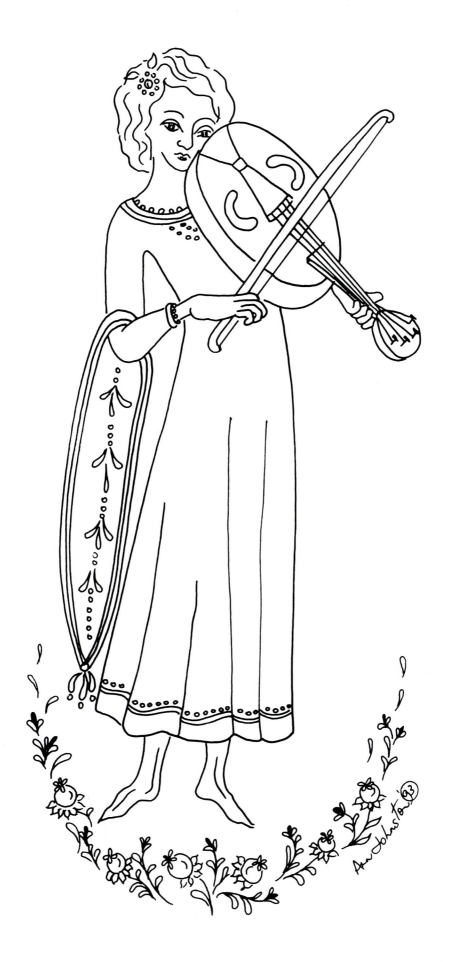

Lady Playing a Violin

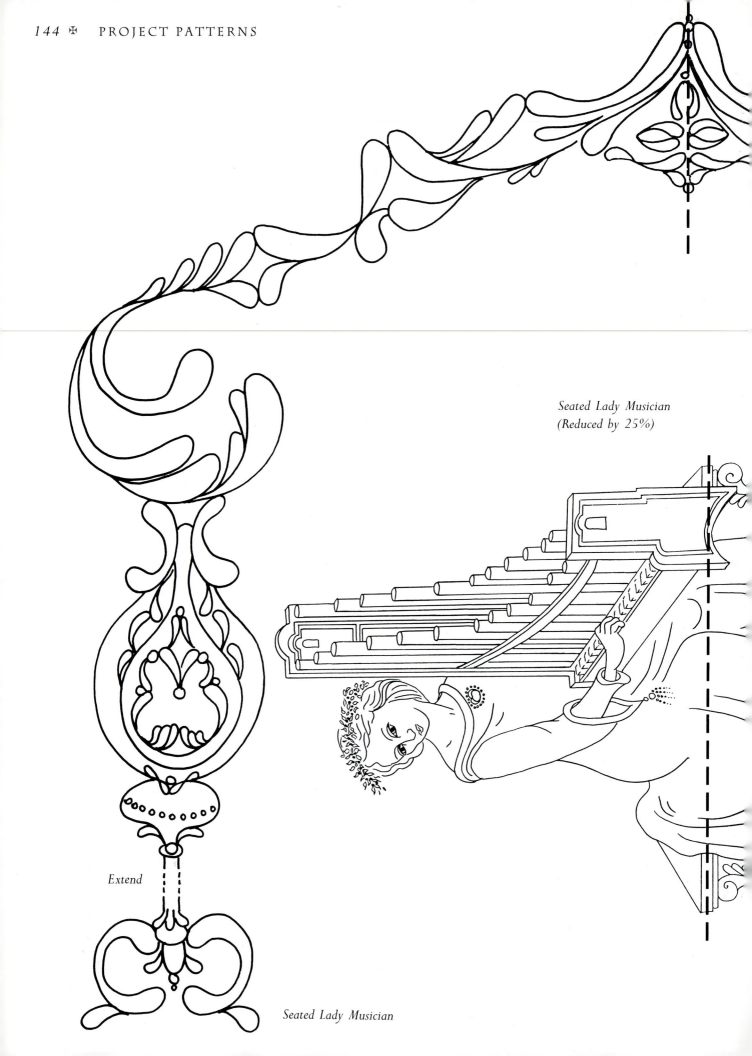

Seated Lady Musician
(Reduced by 25%)

Extend

Seated Lady Musician

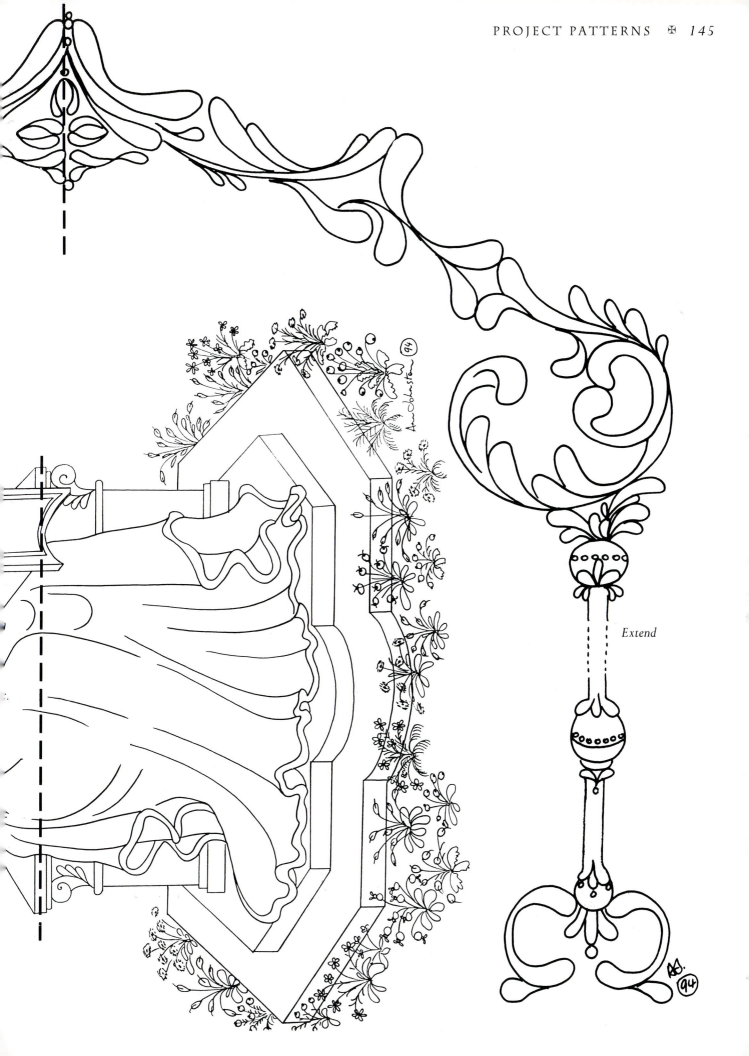

Extend

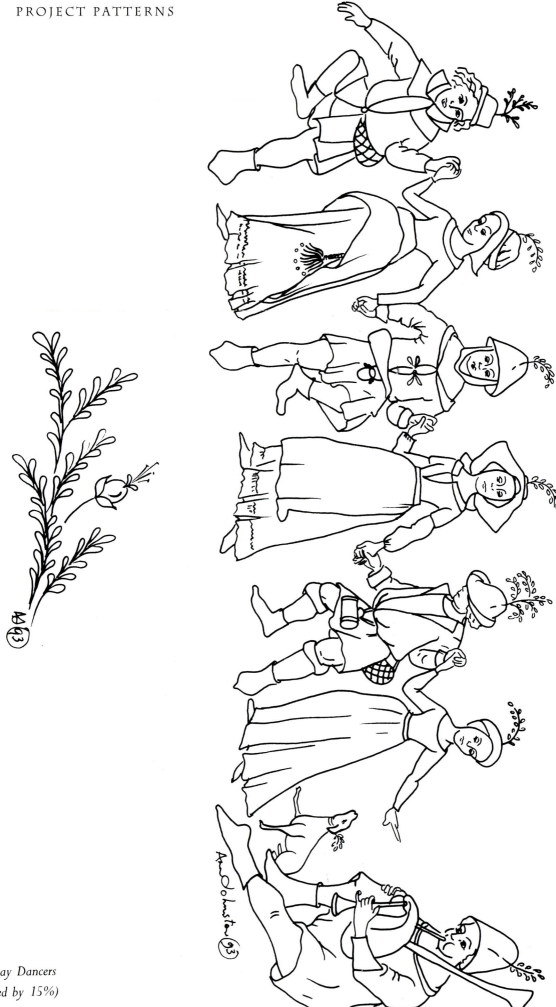

May Day Dancers
(Reduced by 15%)